INDIA

THE DEFINITIVE IMAGES

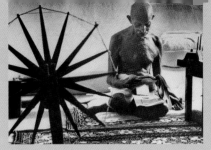
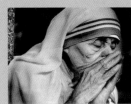

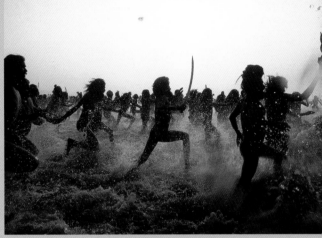

INDIA

THE DEFINITIVE IMAGES 1858 TO THE PRESENT

PHOTO EDITOR **PRASHANT PANJIAR** • INTRODUCTION **KHUSHWANT SINGH**

DK

PENGUIN
VIKING

LONDON, NEW YORK, MELBOURNE,
MUNICH, DELHI

First published in 2004 by Penguin Books India (P) Ltd and Dorling Kindersley
Limited, London

ISBN 0670-049654

Book design by Bena Sareen

Printed and bound at
Ajanta Offset, New Delhi, India

see our complete catalogue at

www.dk.com
www.penguinbooksindia.com

Front cover photographs:
(centre) Photo copyright © Steve McCurry / Magnum Photos
(top right) Photo courtesy Photo Division
(centre) Photo copyright © Raghu Rai
(bottom) Photo courtesy Kamat Foto Flash
Back cover photographs:
(top) Photo copyright © Steve McCurry / Magnum Photos
(centre) Photo courtesy Tendulkar Family Album
(bottom) Photo courtesy Kamat Foto Flash

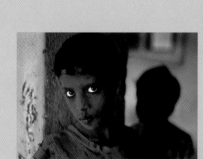
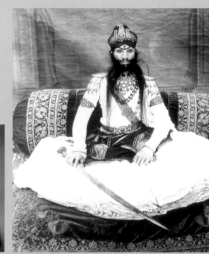
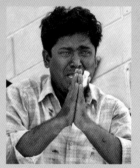

Khushwant Singh

This book is a photographic history of modern India—political, social and cultural. Equally, it is about timeless India. Had this to be done in words, it would have been an impossible enterprise. Photographs tell a story more eloquently and effectively than learned articles, books on contemporary history or novels. But putting together such a collection could not have been easy. Selecting the images that add up to a visual history of modern India is in itself a difficult task. The greater problem, however, is choosing a starting point, always a tricky business when dealing with a civilization and society as complex as ours.

The most acceptable option would be the uprising against British domination of northern India in 1857, described by patriotic Indians as the First War of Independence, by English historians as the Sepoy Mutiny. It marked the formal end of the Mughal dynasty with the exiling of Emperor Bahadur Shah Zafar to Rangoon. There he spent his remaining years writing Urdu poetry and pining for Hindustan; he died a defeated, unhappy man. The picture of the last Mughal on his deathbed in Rangoon is among the most powerful and defining images in this

collection. It is associated with a shift of enormous significance in our history. The British abolished the East India Company in 1858 and the entire subcontinent, extending from today's Bangladesh in the east to Pakistan's North West Frontier Province (NWFP), from Kashmir in the north to Cape Comorin at the southernmost tip of India, became part of the British empire. The process of modernization began almost immediately: in the next twenty years universities were set up in Calcutta, Bombay, Madras, Lahore and Allahabad. India would never be the same again.

An equally good starting point could be the founding of the Indian National Congress in Bombay in 1885. To my knowledge, no photographic evidence exists of this watershed event which in many ways represents the beginning of a process that was to culminate in India achieving independence and becoming a secular, democratic republic. To start with the Indian National Congress was a body of liberal-minded people who felt Indians should have more say in managing their own affairs and larger representation in the services. It had the tacit approval of the government. However, in time it became the biggest and most organized opposition to British rule. The situation changed most dramatically during the viceroyalty of Lord Curzon (1889–1905). Amongst other decisions he took was to partition Bengal into two, roughly as it is divided today into India's West Bengal and Muslim-dominated Bangladesh. This was opposed by the Congress, and even more fiercely by Bengali Hindus,

who fought back with bombs and pistols. The partition had later to be annulled but it began the rift between Hindus and Muslims. The majority of the Muslims moved away from the Congress, seeing it as an organization working for a Hindu India, and supported the Muslim League set up in 1906. Seeds of the partition of the country had been sown. The freedom movement gathered strength under the leadership of Mahatma Gandhi, who had come to dominate Indian politics by 1920 and transformed the Congress with his philosophy of non-violent resistance. However, but for short periods like the Khilafat agitation, by and large Muslims, except in Sindh and NWFP, continued to lend their support to leaders of the Muslim League.

During the First World War most Indians including Gandhi stayed loyal to the British rulers. The break came with the massacre in Jallianwala Bagh (13 April 1919) after which the vast majority of Indians finally turned their backs on their foreign rulers. By the Second World War it was clear that the British would relinquish their power in India. However, India would no longer be one country but divided into three parts, with the predominantly Muslim north-west and East Bengal forming a new state, Pakistan.

The partition of the country took a heavy toll of life, with close to ten million people being uprooted from their homes. Over five million Hindus and Sikhs left western Pakistan and

crossed into India for safety, and almost the same number of Muslims were forced to flee from India into Pakistan. In the process of exchange of populations nearly a million were butchered.

India as we know it today is largely a product of how the British administered the country, what happened during the freedom movement and the partition of the subcontinent along religious lines. All these can be linked in some manner or the other to that transforming event of 1885. It is not surprising that a good number of the pictures in this book are of freedom fighters like Gandhi, Nehru, Bose (all of whom were associated with the Indian National Congress), Bhagat Singh and Chandrashekhar Azad; of protest movements like the Dandi march; and of Partition and its aftermath. This is as it should be: what can be more defining, more memorable an image of our recent history than Gandhi at his charkha, or the train overflowing with refugees after Partition?

India gained sovereign independence under Prime Minister Jawaharlal Nehru and opted to remain a secular state. Pakistan under its first President, Mohammed Ali Jinnah, chose to become an Islamic republic. Relations between the two neighbours were never friendly; they fought three major wars of which the third, fought in 1971, gave India a decisive victory and cut asunder the two wings of Pakistan, with Bangladesh emerging as an Islamic republic with

Bengali as its national language. The victory also made the then prime minister of India, Indira Gandhi, an iconic figure. The Emergency she imposed in the country four years later, flouting all the accepted principles of democracy, was the direct result of this unprecedented power and popularity that made her intolerant of any opposition. Kishor Parekh's picture of fighters in the streets of East Pakistan and Raghu Rai's photos of Mrs Gandhi with her cabinet and of her torn posters after the 1977 elections give us the essence of these events.

Since 1980, India has lost two prime ministers to terrorism; thousands have died in earthquakes, industrial accidents and riots; society has become more polarized than at any other time since Partition; goons and criminals have entered legislative assemblies and shamed the country. The last two decades have been depressing times. The pictures from this period that we remember are mostly disturbing images. There have been few things to cheer about: our cricket team winning the world cup in 1983, Indian beauty queens winning the Miss Universe and Miss World titles in the mid 1990s and of course India's victory in the Kargil war in 2001.

If we are still hopeful of our future, the optimism comes from the resilience of ordinary life. Photographers over the years have captured some beautiful moments that show how life continues, as it has for centuries, despite all upheavals. These images of timeless India form

the opening section of the book: children sporting in the water, women welcoming the monsoon rains, people crowding bazaars and fairs. Then there is cinema. Showmen like Raj Kapoor and stars like Amitabh Bachchan, Rekha and Madhuri Dixit have provided us solace and entertainment for years; they and their heirs continue to sell dreams and rule the imagination of their countrymen.

■

I am not sure when the camera first came to India. My guess is that it was probably in the second half of the nineteenth century. Almost certainly it was the big box on a tripod using glass plates and manually operated by the photographer with his head stuck under a black cowl. He ordered his subjects to stay still while he took the lens off his contraption for a couple of seconds and put it back. So we have stills of viceroys and vicereines, of Indian maharajas, maharanis and princes dressed in their regalia, of tiger shoots and nautch girls. Photography came into its own with the invention of small cameras using celluloid films. With this came demands from newspapers which wanted to illustrate news and features with pictures. Every important newspaper and magazine had its own photographers. The more successful of these turned into freelance photographers. And yet others made photography into an art like painting: they captured people in varying moods and landscapes of mountains, rivers and lakes as well as the best of painters.

This book contains the work of all these different kinds of lensmen. There are the pioneering portraits of nineteenth-century royalty by Raja Lala Deen Dayal, photographs of epic quality by the Frenchman Henri Cartier-Bresson, romantic and moving images by Raghubir Singh and Raghu Rai, and classics of photojournalism by Homai Vyarawalla and Kishor Parekh. Often the subject makes the photographs timeless: Mother Teresa at prayer; Gandhi's funeral; Nehru making his 'Tryst with destiny' speech at the stroke of the midnight hour on 14/15 August; Nargis and Raj Kapoor singing in the rain in the film *Shri 420*; India's obsession with cricket portrayed through a picture of Sachin Tendulkar aged five wielding a cricket bat; the tragedy of the Bhopal gas leak conveyed through the sightless eyes of a half-buried child and India's exploding population through a solid mass of humanity crowding Churchgate station in Bombay. Each image is worth more than a book because it will stay in your mind for years to come. Together they bring you modern India through its lived moments.

What makes a photograph famous?

Is it the artistic value of the photograph, its sheer beauty, or the manner in which it captures the 'decisive moment' or the 'defining image'? Or is it that over time the photograph has been reproduced so often in the media, in books and even in calendars that it has come to signify the historical event or personality that it shows, and thus becomes famous by association?

Public images—official portraits of presidents, prime ministers and other important people, propaganda pictures of our nation's achievements, mass-produced images of godmen, stars and models—these are what we are most familiar with. They crowd our everyday lives, and we often don't realize to what extent they affect our memory, reinforce stereotypes and determine how we regard people and events in our history. Some images, in fact, have become so commonplace that we barely register their presence. Have you ever looked carefully at our currency notes? A leading English daily recently informed us that the 500-rupee note is referred to as a 'baldie' by the 'Now' generation. This confused me, till I read on and discovered that the term comes from the photographic image of Mahatma Gandhi that adorns all our currency notes. (Just another one of the many ironies of our nation where an ascetic who aimed to renounce all material possessions may finally come to be associated only with money.)

The politician uses photographic images of himself, hands folded, smiling at you, to get you to believe in him, to trust him with your life and money. The handout photo, whether an official picture of the Pokaran blast from the government or a flattering portrait of an industrialist from a PR agency, is meant to do the same. No cult is complete without mass-produced

photographs, even if they are cheap cut-and-paste jobs like the postcards of Roop Kanwar that were hawked in their thousands after her sati in Deorala.

Not every image that becomes part of public memory is the result of a planned public relations exercise. Some pictures have become famous because they were given a prominent place in the media: Parveen Babi's photograph on the cover of *Time* magazine, for instance, or the more recent video-captured still image of Bangaru Laxman allegedly taking a bribe. As the age of the media progresses, we will see many more images like the latter.

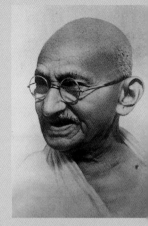

When I was asked to edit this book of the most famous photographs of India that add up, in a sense, to a visual history of the country, it struck me that it was important to investigate which photographic images the average Indian knew best. Could we, by studying these images, arrive at some understanding of our nation? That seemed to be an interesting idea to pursue. Since there is no complete documented catalogue of Indian photography, the only way left was to speak to a cross section of people—photographers, writers, journalists, friends and even people I met socially—and coax them to remember images. I started with an initial small selection of images collected from magazines, books and individual photographers. I would show them around and seek people's reactions to them. How easily did they recall these images? What did they signify to them? The exercise also helped to jog the memory of my diverse jury, and my list grew.

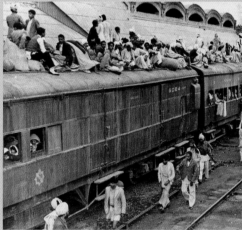

Interestingly, many of the people I spoke to first listed out the most important events and personalities in our history and then tried to associate photographs with them. However, this did not always work, for the simple reason that there was often no single striking photograph

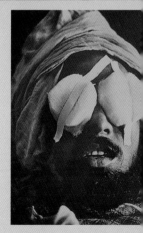

Photos courtesy (top) Gandhi Smriti; (centre) Photo Division; (bottom) Raghu Rai

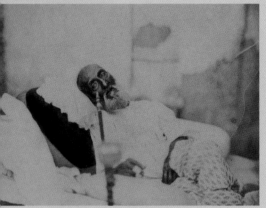

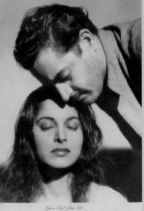

that one could connect with a significant event or person. For instance, the 1984 anti-Sikh riots are among the most traumatic episodes of our recent history, but photographs of the violence are limited as camerapersons were constantly under threat from armed mobs and were prevented from recording the true ghastliness of the carnage. Since then this has become the trend: in Ayodhya and in Gujarat photographers were the first targets of the rioting mobs. Similarly, there have been several towering personalities in India's history but not all have photographs associated with them that pass the test of being memorable. So do not be surprised if you find some obvious events and people not represented in this book.

After I had a shortlist, I pruned it further. The idea central to my final selection was that for a photograph to be truly memorable, it had to have the intrinsic qualities that make good photographs great. It was not enough for an image to represent an important aspect of our history or our unique physical and cultural attributes; to be part of a book such as this one, it had also to transcend the 'moment' when it was made. So quite a few well-known but unremarkable pictures were discarded. However, there are some public images that may not pass every test of aesthetics and technique but are unquestionably memorable and have become part of our national consciousness. I decided to include such images as a tribute to their genuine power. In this category I would place pictures of the midnight ceremony where Nehru is being sworn in as India's first prime minister, the formal surrender of the Pakistani Army in Bangladesh in 1971, and Kapil Dev and Mohinder Amarnath with the cricket World Cup, 1983.

We all know that photographs are a means by which we relive important moments as well as everyday life. Until the advent of the moving image, still photographs dominated our ways of

Photos courtesy (top & centre) Photo Division; (bottom) Kamath Foto Flash

remembering events, people and places. Though cinema and now television have forever altered our visual habits, they have not been able to replace the still photograph. Commentators on photography have said that in moving pictures the status of the individual image is devalued. The still photograph, however, forces us to concentrate, to contemplate. Which is why it leaves such a lasting imprint in our memory.

Photography is 163 years old in India. Many great photographers, both Indian and foreign, have worked in India, producing some exceptional images. Many of these, inevitably, portray episodes and people that have, for better or worse, shaped our country, or at least our perception of it. These are the images, belonging to our collective memory as a nation, that I have attempted to bring together in this book. It is, to me, a photographic time machine, through which we can journey into our recent past and arrive at some understanding of who we are and what we want to be.

This book would not have been possible without the help and cooperation of all those unsuspecting people, my many friends, whom I ambushed with my list of photographs and who helped me arrive at the final list. My special thanks to S. Paul, Sanjeev Saith and Raghu Rai for guiding me at all times, and to S. Rakshit, U. Suresh Kumar, Abhijit Bhatlekar, Atul Loke, Swapan Nayak and Sanjay Malik for the invaluable help they gave me on this project. I am thankful also, of course, to all the contributing photographers, Indira Gandhi National Centre for the Arts and other agencies.

— Prashant Panjiar

Timeless India

'It is not only a country and something geographical,' the German writer Hermann Hesse said of India, 'but the home and the youth of the soul, the everywhere and nowhere, the oneness of all times.' In a civilization as ancient as India, in a country as vast, crowded and diverse, every kind of human experience is magnified. There are too many people living too close to each other; there is too much religion and too much emotion; and nature is still very much our master. But all this also gives India its unique resilience, a quality that has endured through the centuries. For better or worse, people here have succeeded in making better terms with life in the raw, with the incomprehensible phenomenon of time, and with the still unsolved mystery of death.

Henri Cartier-Bresson

Muslim women praying on the slopes of Hari Parbat Hill,
Srinagar, Kashmir, 1948

Best known for his concept of the 'decisive moment' in photography, Henri Cartier-Bresson
visited India in the late 1940s. Apart from famous pictures of Gandhi, Nehru and other
Indian leaders, Cartier-Bresson also captured scenes of Indian life as the country passed
through its most decisive phase—its birth as an independent nation.

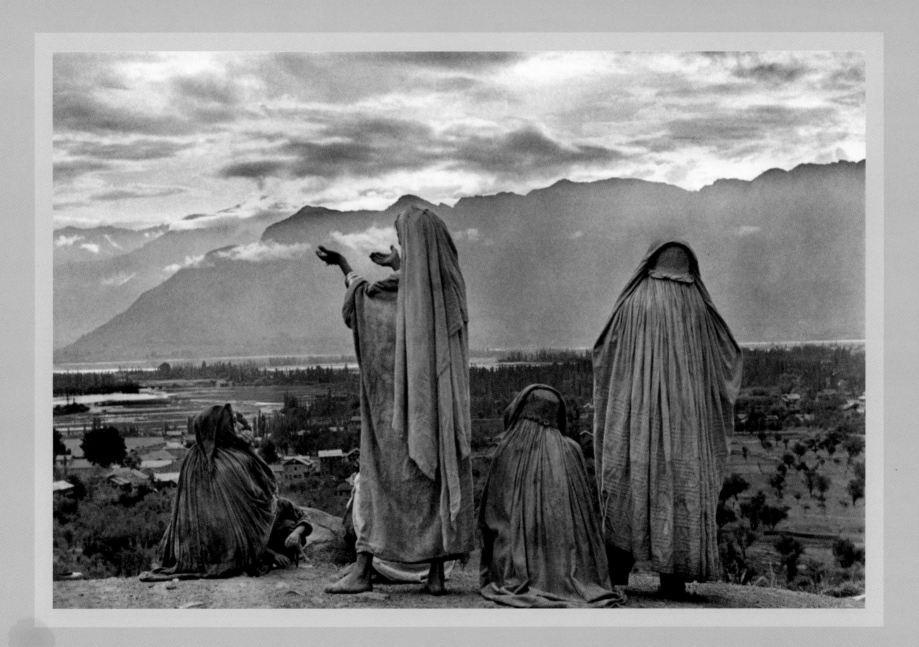

Raghubir Singh

Swimmers and diver, Scindia Ghat, Banaras, 1985

Part of Raghubir Singh's book on the Ganga, which charts the river's progress from its source to its mouth, this photograph is perhaps the most famous image of Banaras and has been reproduced in numerous publications. The Ganga was Raghubir Singh's favourite subject; he kept returning to it to capture the lyricism of Indian life.

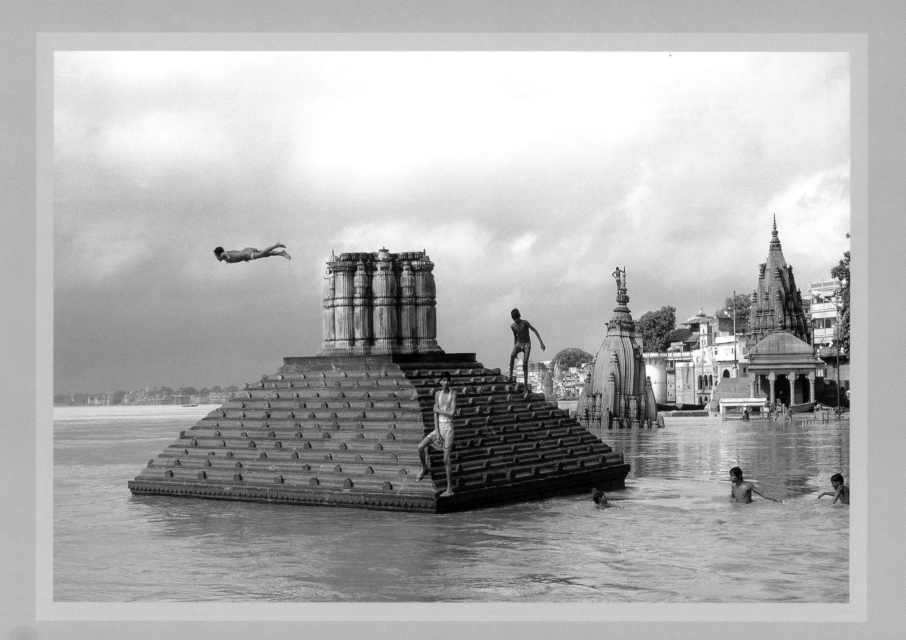

Raghu Rai

A Muslim woman at evening prayers (namaz) in her home in Old Delhi, 1982

'I met Saeed Khan in Old Delhi while shooting for my book on Delhi in the early 1980s. He invited me to his home deep in one of the by-lanes leading off Jama Masjid. He claimed it was the highest point in Old Delhi, from where I could get the best view of the city. But I saw another rooftop next to his house that seemed even higher up, and that was where I wanted to go. Saeed took me there; the house belonged to a relative of his. It was a late summer evening and the rooftop was alive with people flying kites, or just sitting around gossiping. To my left was the enormous Jama Masjid, to my right New Delhi's tall buildings and straight ahead I could see the Yamuna in the distance, and smoke rising from the power station. The rest of the mishmash, khichri city was behind me. I spent quite some time up there. At twilight, when the light was fading and I was climbing down the steps, I saw this woman at her namaz through a doorway directly opposite, right in front of Saeed's house. Since I had been concentrating on the Jama Masjid that day, I kept the monument with the clouds above it in the frame as I composed this picture which to me contained all that was necessary to fulfil my experience of the day.

'A large framed print of this photograph still adorns a wall of Saeed Khan's home, though, unfortunately, Saeed Khan himself is no more. As for the lady in the picture, she was a relative of Saeed's who later married and went away to live with her new family outside the walled city.'

Raghu Rai

Khari Baoli, Delhi, 1964

'It was the first time I had walked in the Old Delhi area—with a 50 mm standard lens, which was what I could afford at the time—and I was mesmerized by the narrow lanes, the crowds and the variety of traffic: everyone moving in different directions. However, after the initial excitement I just stood there helplessly—there was so much happening around me that I felt I couldn't possibly record it properly without a wider lens. Then I remembered a friend of mine who owned an ittar (perfume) shop in the area. He had always told me that I should photograph the locality because I would love it. So I went up to his shop on the second floor and from his window took a few pictures of the busy square below. I was sure the photographs would be nothing more than passable. But when I made prints and showed one of them around, I was pleasantly surprised by the reactions. This picture, one of my earliest, continues to elicit a great response from viewers.'

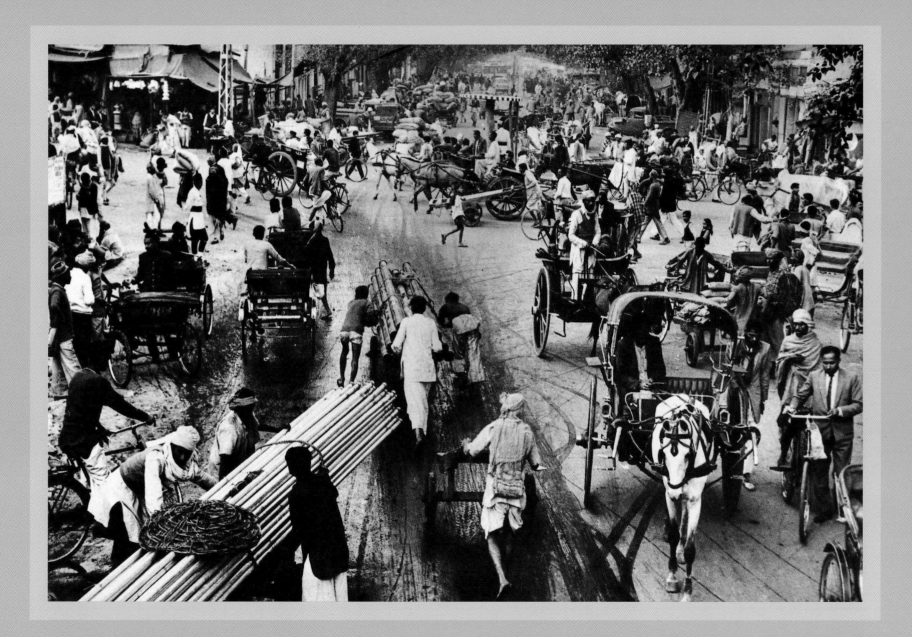

Sebastiao Salgado

The Mahalaxmi Dhobighat, Bombay, 1995

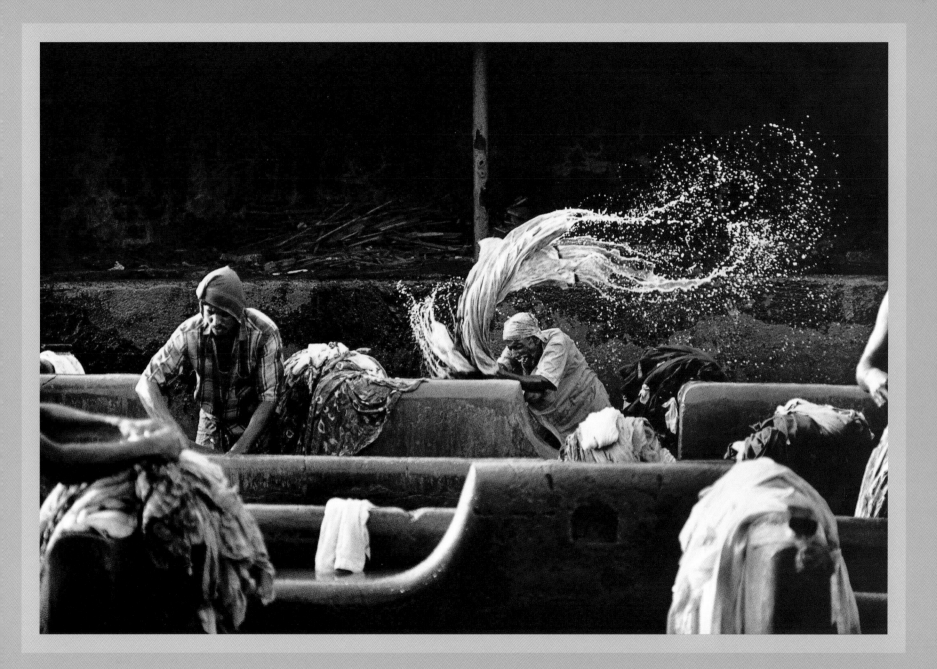

Sebastiao Salgado

Churchgate Station, Bombay, 1995

This simple image of a common, everyday scene in Bombay so eloquently sums up the phenomenon of migration and overcrowded cities that it has been reproduced over and over again in several publications. The picture was taken during Salgado's seven-year project on population movements around the world. Salgado was in Bombay to portray how urban centres grow due to massive rural exodus. His work resulted in the books *Migrations* and *The Children*, which were published in 2000 in seven editions. An accompanying exhibition is touring the world.

Photo by Sebastiao Salgado / Amazonas Images

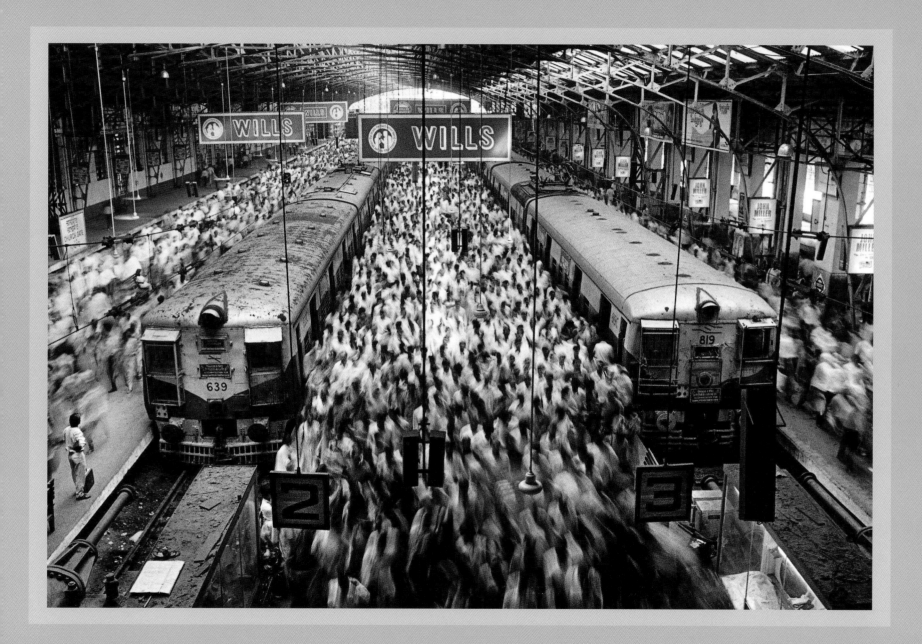

Steve McCurry

Taj and train, Agra, 1983

'Trying to tell India's story in pictures, I spend time in its railway stations, watching the swirl of life each time a train pulls in. But the trains are often late, and people seem to wait endlessly. They camp out in the stations; goods and services are exchanged; chaiwallahs ply carriages with their wares; cows and, occasionally, monkeys forage for food. And all the while the entrance halls reverberate with the raised voices of passengers competing for tickets—the clamour of the crowds is a constant assault on the senses. India's stations are a microcosm of the country beyond, and in the commotion of travel, you can feel the continuity between past and present.

'This photograph was taken when I was working on a magazine assignment on a train journey across South Asia. Walking down the track from Agra Fort Station, I was amazed to see the Taj at the back of the enormous rail yard. So I waited, and suddenly these steam locomotives started moving in front of the Taj, and I had my picture.'

Photo copyright © Steve McCurry / Magnum Photos

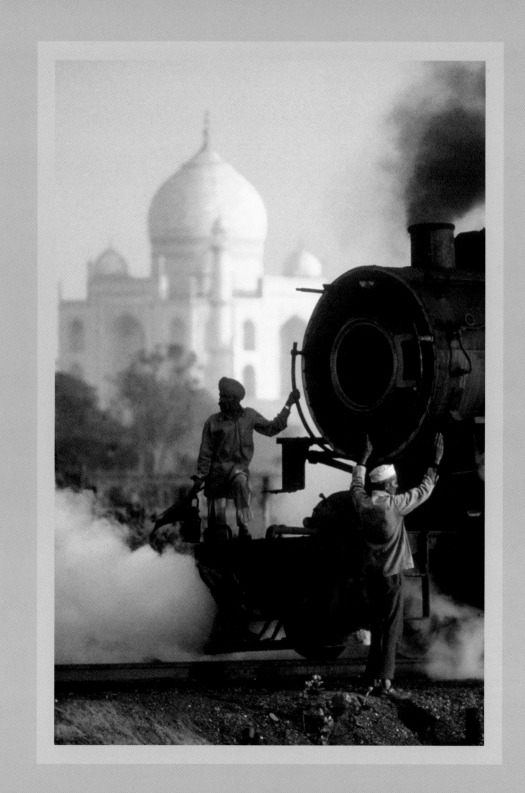

Steve McCurry

Dust storm, Rajasthan, 1984

'I was driving through the desert to Jaisalmer on the India–Pakistan border. It was June and as hot as the planet ever gets. The rains had failed in this part of Rajasthan for the past thirteen months. I wanted to capture something of the mood of anticipation before the monsoon. As we drove down the road, we saw a dust storm grow—a typical phenomenon before the monsoon breaks. For miles it built into a huge, frightening wall, moving across the landscape like a tidal wave, eventually enveloping us like a thick fog. As it arrived, the temperature dropped suddenly and the noise became deafening. Where we stopped, there was a group of women and children working on the road, something they are driven to do when the crops fail. They were barely able to stand in the fierce wind now and clustered together to shield themselves from the sand and dust. I tried to take pictures. The road workers didn't even notice me. In the strange orange light, with the wind howling savagely around them, they sang and prayed. Life and death seemed to hang in the balance.'

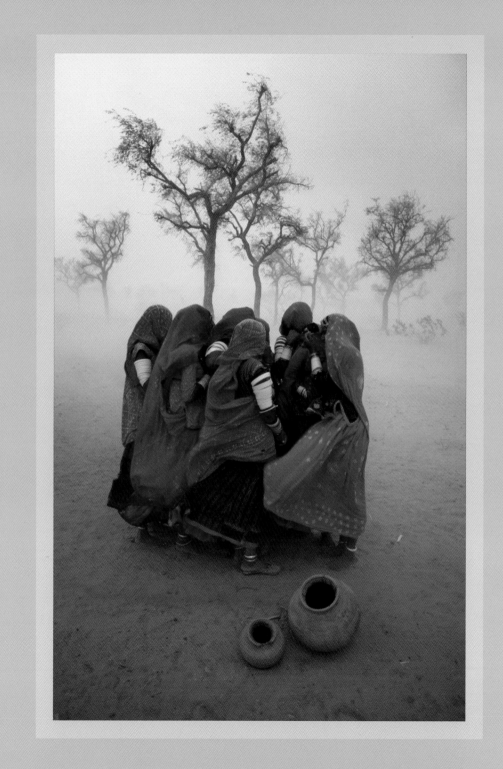

Raghubir Singh

Women caught in monsoon rains, Monghyr, Bihar, 1967

'In Rajasthan, my homeland, rain is scarce. So when it thundered and poured, all of us children would rush to the rooftops to soak to the very bones in the life-giving monsoon. After three long and sun-scorched months, the rarity of rain made me long for and love the season of showers and breezes. I have never lost my love for the monsoon rains. It is shared by all Indians of all times.'

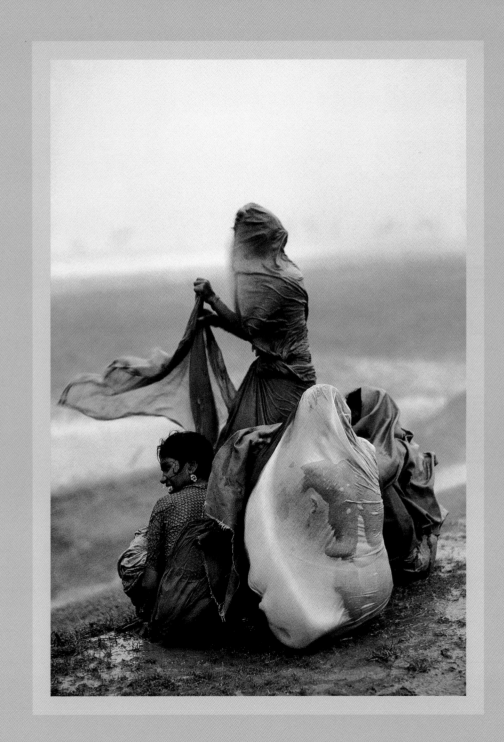

Brian Brake

Monsoon girl, 1960

New-Zealand-born photojournalist Brian Brake developed the idea of a story on the monsoon in India in the late 1950s, and convinced *Life* magazine to support the project. After a few exploratory visits to research the subject, he spent nine months in India during 1960-61 shooting the images that make up his classic photoessay 'Monsoon', which first appeared in the 8 September 1961 issue of *Life*. This memorable close-up of a young woman, her face lifted up to the rain, communicates the deep, almost spiritual connection Indians have with the monsoon. Interestingly, this photograph, which became the signature image for the essay and was widely reproduced, was not shot outdoors in a monsoon shower but staged in a studio. The model is the now famous actor and director Aparna Sen, a teenager at the time.

Photo copyright © Brian Brake / Collection of Te Papa Tongarewa, New Zealand (CT.035625)

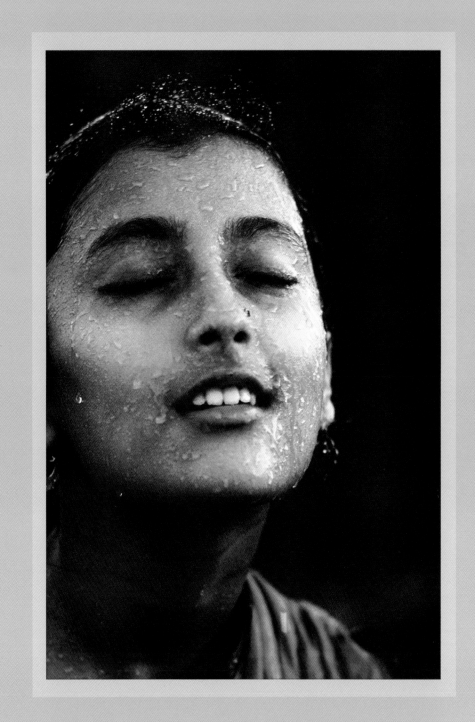

Steve McCurry

Red boy, Bombay, 1996

'Ganesh Chathurti, the birthday of the god Ganesh, draws millions to Bombay to honour him in a raucous festival, as much carnival as sacred event. Thousands of statues of Ganesh are carried on decorated floats, accompanied by dancing and the beat of drums, to the Arabian Sea where they are ritualistically immersed en masse. Powder bombs cover every surface and fill the air with colour—a riot of red, green and magenta. In the fall of 1996, I was working on a story for *National Geographic* about India's fifty years of independence when I met this young devotee pausing for a rest on a porch along the procession route. A fleeting moment of calm like this one amidst the incredible fervour and intensity of a festival is a notion that has always captured my attention and keeps bringing me back to India.'

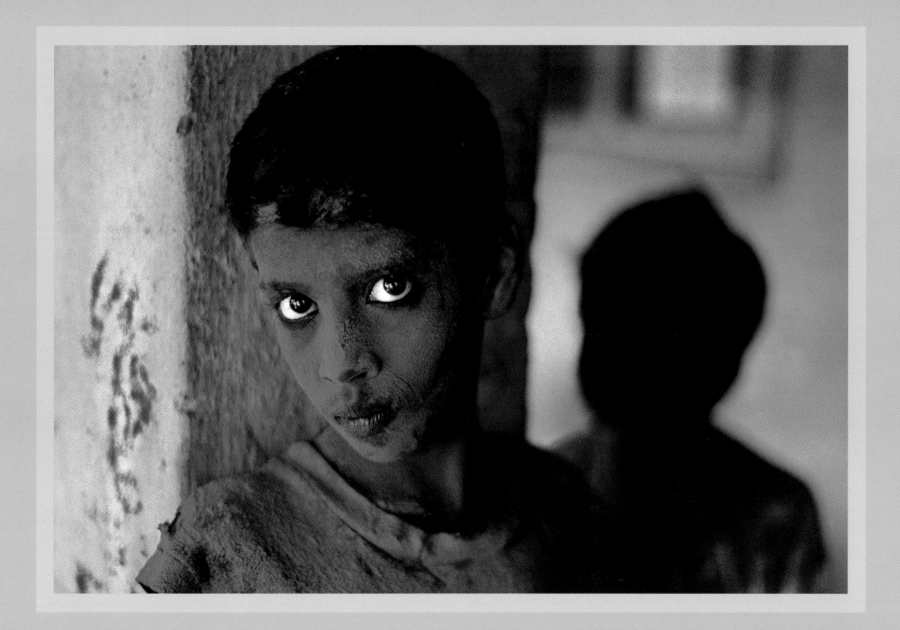

S. Paul

Urchins running down a hillock, Village Bansi, Haryana, 1971

The romantic, idealized vision of innocent childhood captured on film has always been the staple of photography. This image and the one overleaf, repeatedly printed in the media, have come to exemplify this genre in India.

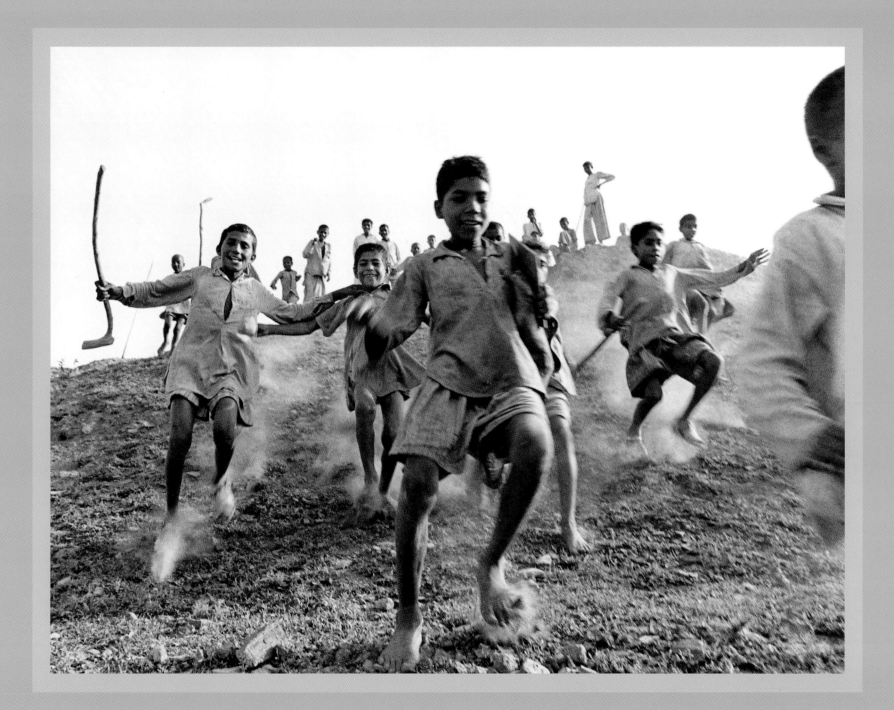

T.S. Satyan

Children diving into water on a hot day, Bombay, 1970

'This photograph was shot on a hot, humid afternoon in Bombay in 1970. I was to meet my friend Mitter Bedi, the famous industrial photographer, for lunch. When I reached Mitter's studio located behind the Gateway of India, he was still busy shooting an ad picture. He would need another half hour to complete the shoot, he said, suggesting that I take a stroll around the Gateway to take "some good pictures". Barely a minute into my stroll, I came upon a group of four naked street children on the curb of the waterfront. They were diving into the sea at regular intervals to cool themselves. I pointed my camera at them and quickly shot five or six frames. Even as I was taking the pictures, I knew I had at least one wonderful frame and told Mitter so when I returned to his studio. "If that is the case, let us postpone our lunch and develop your film first," he said and went into his dark room. He was all smiles when he returned with the wet film in his hand, proudly proclaiming that I had indeed shot a wonderful picture. The success was celebrated at the Taj Mahal Hotel nearby where we both ate a little more than was necessary!'

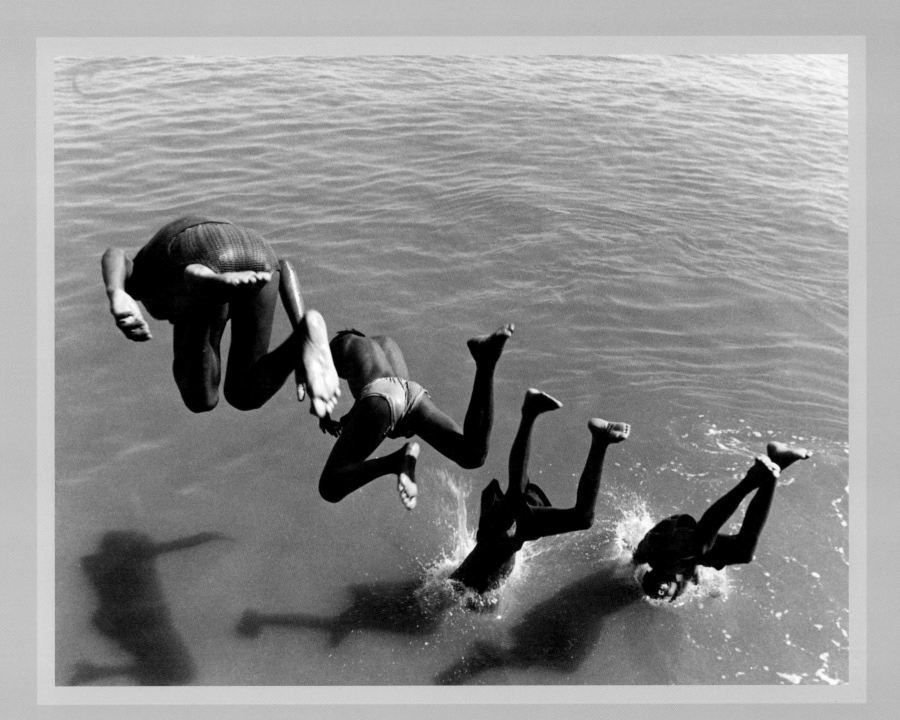

Raghu Rai

Ugrasen ki Baoli, Delhi, 1976

'In the summer of 1976, I was working with the *Statesman*. On days when there wasn't much work, I would wander around the city looking for images. One afternoon I found myself at Ugrasen ki Baoli, a large, partially covered step well believed to have been built over a thousand years ago. It is located in Connaught Place, the busy commercial centre in the heart of New Delhi, but few people know of it and it has been neglected for years. As I entered the baoli and went down the steps, I was overpowered by the peace and the sense of time standing still. From the outside one gets not even a hint of what lies within the rubble-and-stone walls. There was a small group of boys diving and swimming in the cool waters. For that one incredible instant, as I froze the leap of this boy on film, two different Indias, at least a millennium apart—the ancient, quiet baoli and the modern skyscrapers of bustling Connaught Place— seemed to coexist beyond time.'

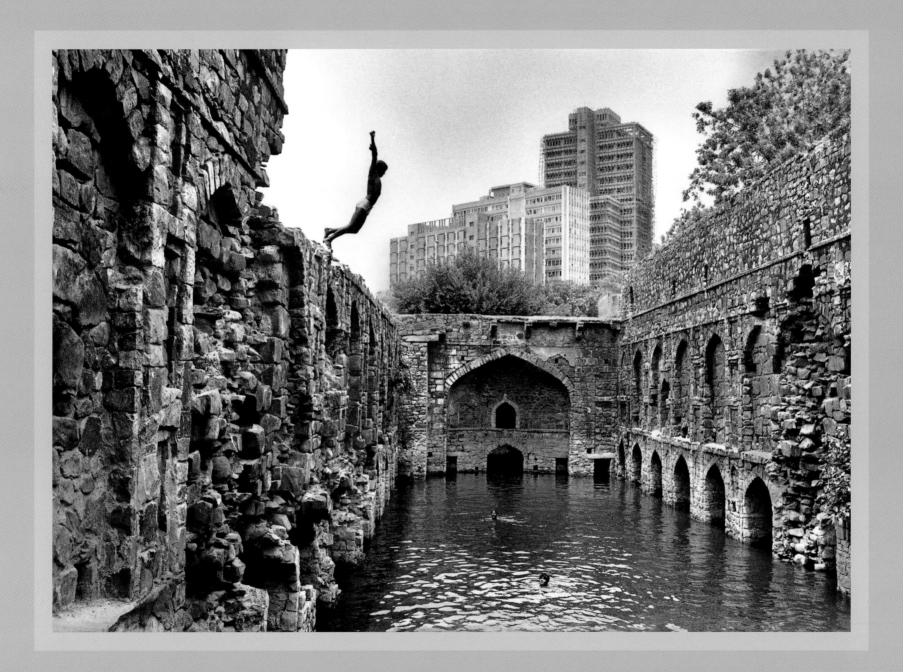

Henri Cartier-Bresson

Refugees exercising in the camp to drive away lethargy and despair,
Kurukshetra, Punjab, 1948

Following Partition, over 300,000 refugees from Pakistan were accommodated in refugee camps set up in
Kurukshetra for more than a year till they were relocated. This is one of the rare images of how life went
on despite the tragic upheaval.

Photo copyright © Henri Cartier-Bresson / Magnum Photos

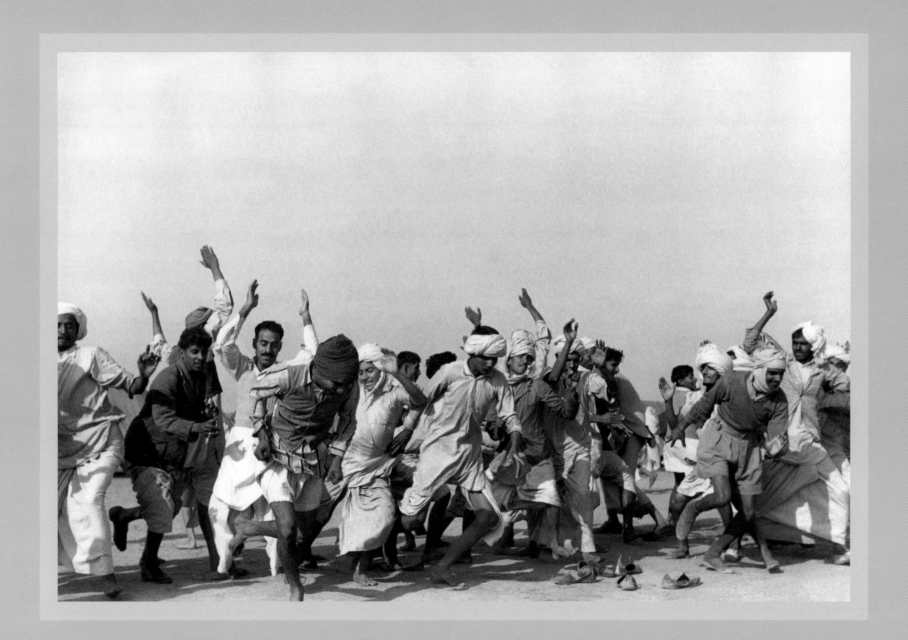

Prashant Panjiar

Naga sadhus charge into the holy waters of the Sangam at the most auspicious moment for bathing on Makar Sankranti during the Maha Kumbh Mela, Allahabad, 2001

'Once every twelve years, when Jupiter enters Aquarius and the Sun enters Aries, millions from all over India gather at the site of the confluence of the Ganga, Yamuna and Saraswati rivers for the Maha Kumbh Mela, the biggest and possibly the most ancient religious fair in the world. Devotees take a dip in the sacred waters, believing that their sins will be washed away. This is India at its most unchanging—it could be 3000 years ago; it could be today.'

Photo courtesy Outlook

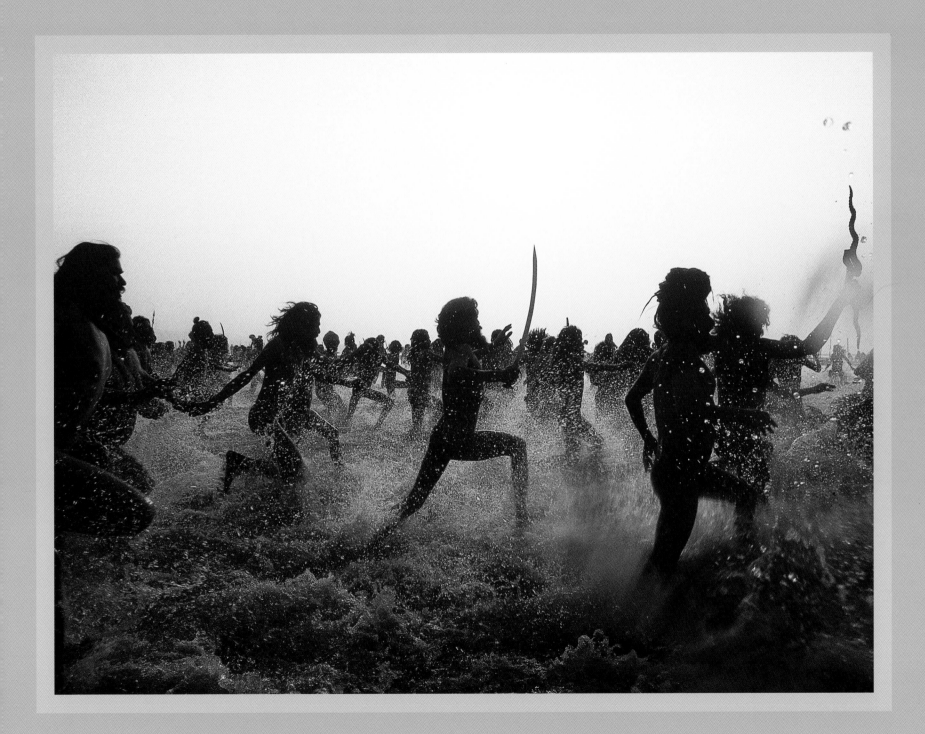

Raghu Rai

Burning ghats, Banaras, 1994

'It was a busy morning on the burning ghats of Banaras—several bodies being cremated at the same time, smoke from the pyres rising from all directions, the air thick with the peculiar smell of the cremation grounds. The soft early morning light, the ghats seen through the haze and people standing around like lost apparitions . . . it was as if a spell had been cast.'

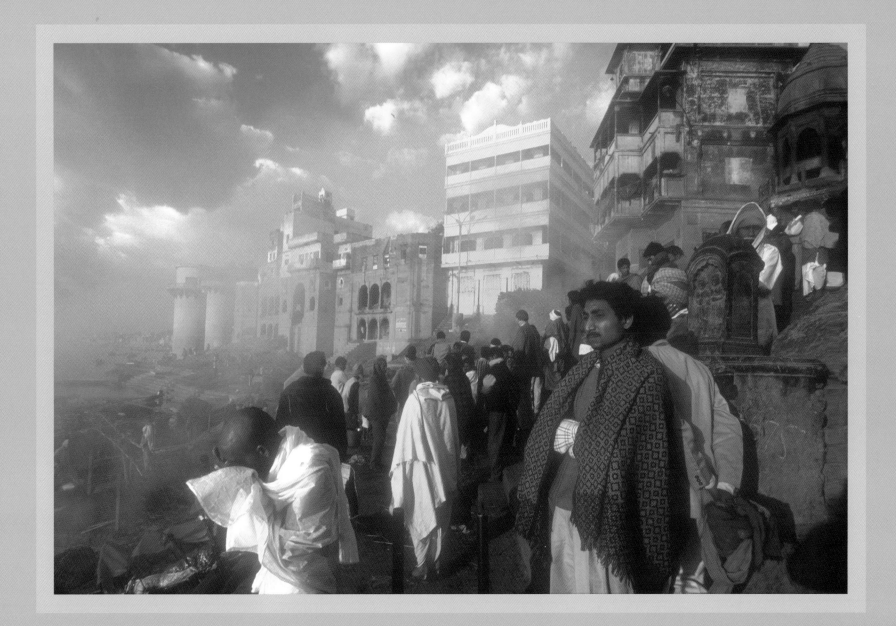

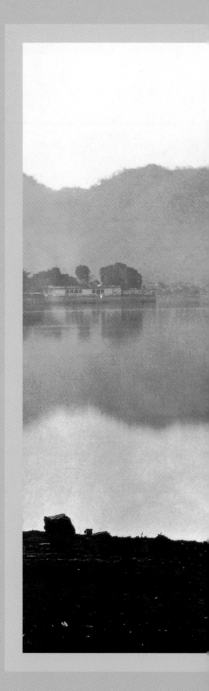

Colin Murray

Udaipur Lake Palace, 1871-72

Photo courtesy Freer Gallery of Art Photograph Reference Collection, Freer Gallery of Art and Arthur M. Sackler Gallery Archives, Smithsonian Institution, Washington, DC

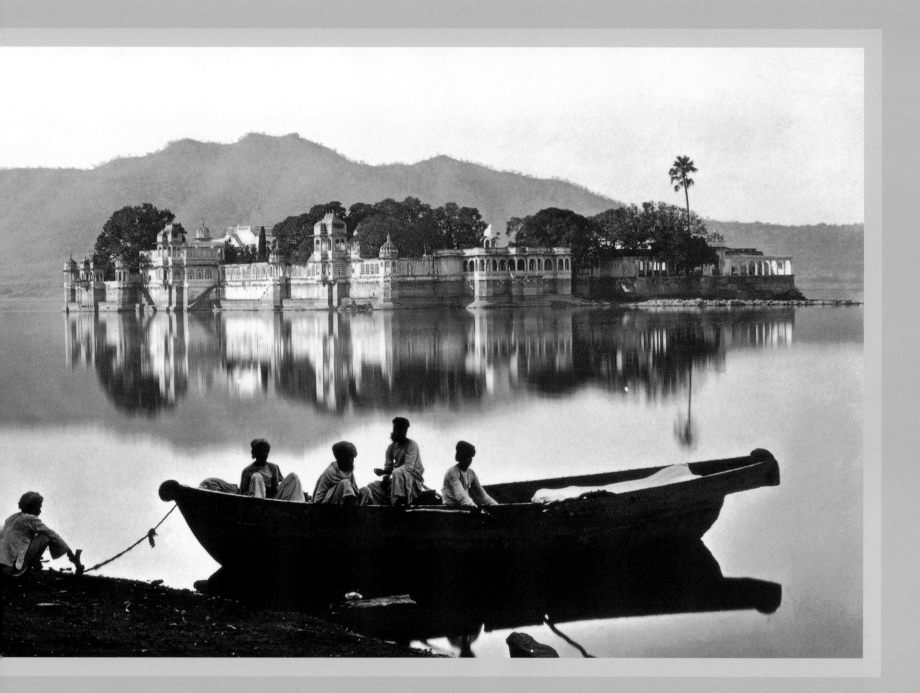

The Road to Freedom

The India that the British became rulers of was hardly a nation. Divided by religion, race, caste and language, the vast mass of the people were indifferent and frequently hostile to the inept princes and nobility who owed loyalty only to themselves; it mattered little to them who their rulers were. The one concerted effort made by Indians to rid themselves of the English took place in the summer of 1857, but the uprising was brutally suppressed.

It was only in the early twentieth century that the independence movement took concrete shape, guided by leaders who were selfless men of character and vision, and the birth of the Indian nation, as we know it today, began. The greatest among these leaders was Mahatma Gandhi, and photographs of him rightly enjoy pride of place in this section. A passionate believer in non-violence, self-reliance and the equality of all men, irrespective of caste and religion, Gandhi took India to nationhood and independence.

Sadly, the last year of the freedom struggle saw him sidelined as the country was partitioned along religious lines, a move that he was strongly opposed to. Ironically, this division became the cause of his death. As he emerged from his daily prayer meeting on 30 January 1948, a Hindu fanatic came up to him, bowed and fired at point-blank range. The Partition and then Gandhi's assassination were hardly auspicious beginnings for free India.

S.H. Dagg

State entry into Delhi, approaching Jama Masjid: The procession of
Indian rulers, 29 December 1902

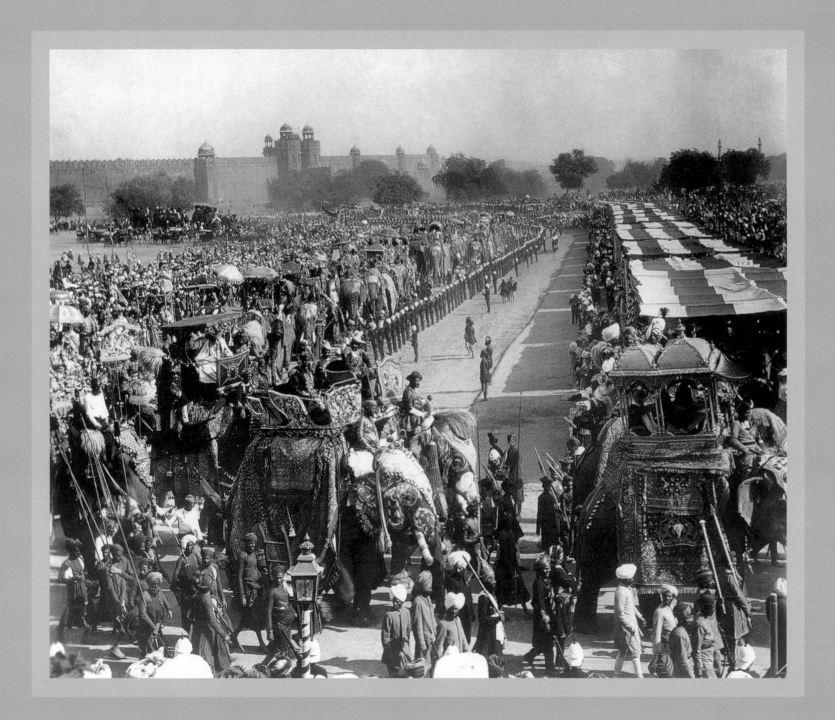

Ganpatrao Abajee Kale

Sir Raghubir Singh, Maharao of Bundi, 1911

Photo 100 (26) by permission of The British Library

60

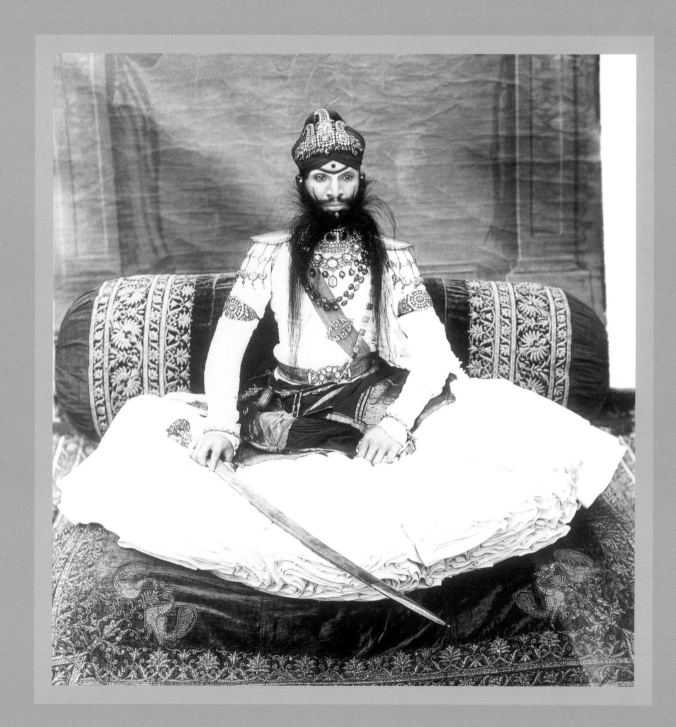

Raja Lala Deen Dayal

Fateh Singh Rao, eldest son of Gaekwad, 1882

Raja Lala Deen Dayal is regarded as a pioneer of professional photography in the country. His pictures of monuments and indigenous tribes and, especially, his portraits of royalty are invaluable records of nineteenth-century India.

Photo courtesy Indira Gandhi National Centre for the Arts

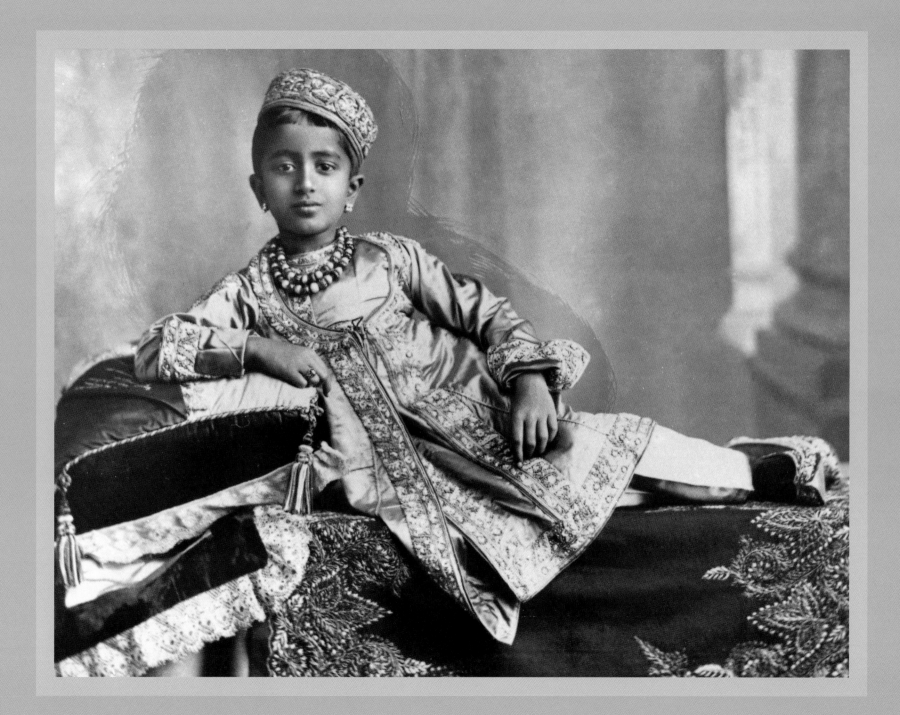

P.H. Egerton

The last Mughal, Bahadur Shah Zafar II, in exile, Rangoon, 1858

After the 1857 uprising failed, Queen Victoria became Empress of India; the Mughal empire, already in decline for over a century, was replaced by the British, and Bahadur Shah Zafar, the last Mughal, was exiled to Rangoon, where he died in 1862. Over the years, Bahadur Shah has come to be seen as a tragic and romantic figure, not least because he was also a poet who wrote some of his finest and most moving lyrics in exile, pining for his homeland.

Photo courtesy Photo Division

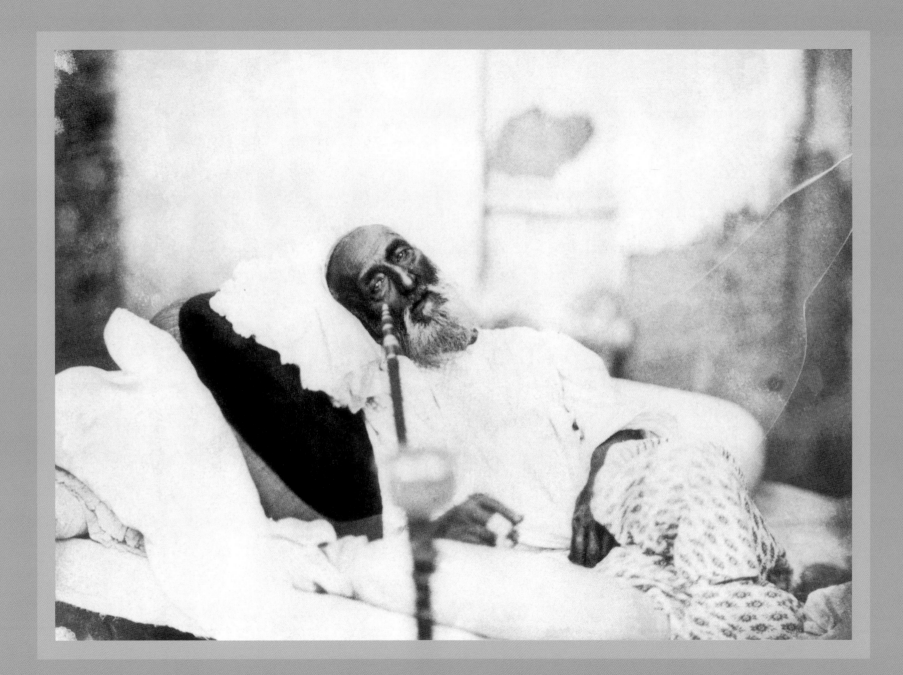

Felice Beato

Interior of Secundra Bagh after the slaughter of 2000 rebels by the 93rd Highlanders and 4th Punjab Regiment, 1858

Felice Beato's images of the 1857 Revolution (the Sepoy Mutiny to the British; the First War of Independence to Indian historians) were thought at the time to be factual, objective records. It has since been proven that this was not the case. Commissioned by the War Office in London, Italian-born Beato arrived in India only in February 1858. His photographs were taken long after the 1857 battles in Delhi and Kanpur, and shortly after the British reoccupied Lucknow in March 1858.

This image of the courtyard of Sikander Bagh Palace (formerly Secundra Bagh) on the outskirts of Lucknow, which shows the bloody aftermath of the attack on the rebel soldiers by British troops under Sir Colin Campbell, is perhaps the most infamous of Beato's photographs. It is believed that he restaged this scene four or five months after the massacre. He not only positioned the horse and the three Indian men but also had disinterred bones scattered in the foreground.

Photo courtesy WCP Collection

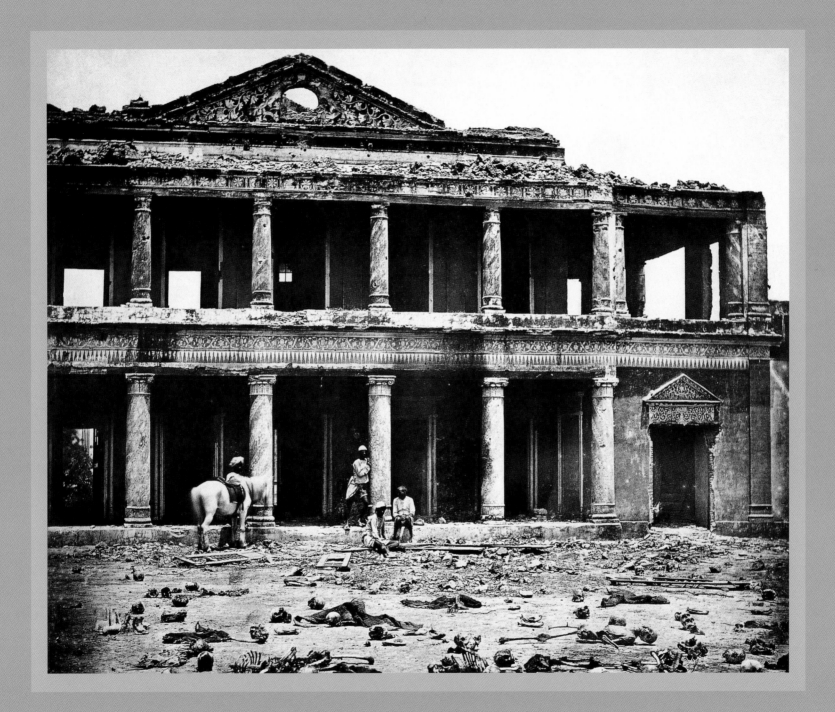

Raja Lala Deen Dayal

Lord and Lady Curzon with first day's bag in camp near Nekonda, Warangal, Hyderabad, April 1902

Photo 55/3 (74) by permission of The British Library

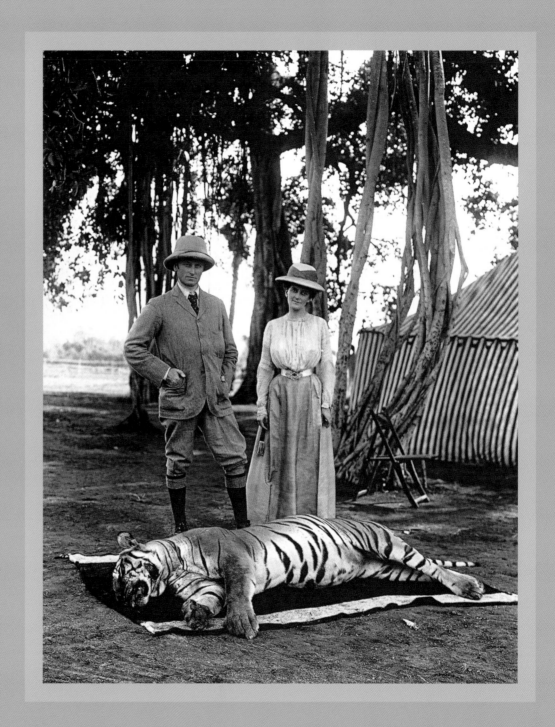

Henri Cartier-Bresson

Lord Mountbatten, last Viceroy of India, Jawaharlal Nehru, prime
minister, and Edwina Mountbatten at Government House, Delhi, 1948

Photo copyright © Henri Cartier-Bresson / Magnum Photos

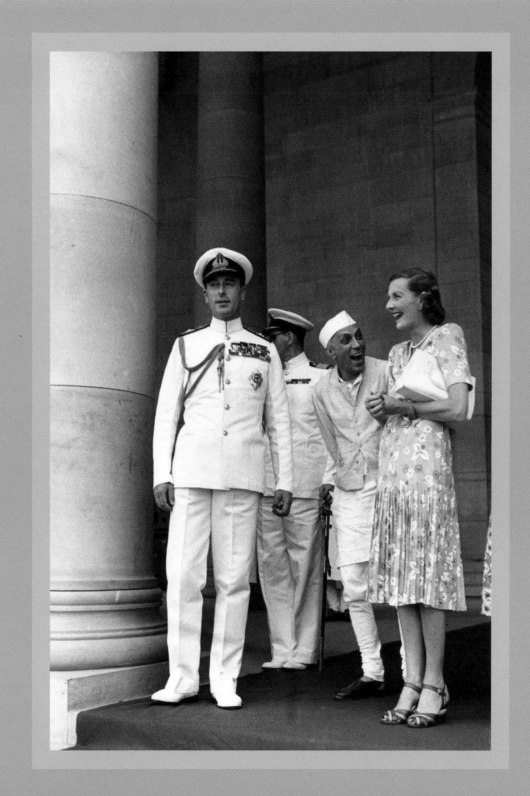

Margaret Bourke-White

Mohandas Gandhi reading as he sits cross-legged on the floor next to a spinning wheel in the foreground as a symbol of India's struggle for independence, 1946

Of all the images of Mahatma Gandhi, this is the one photograph that almost every Indian would have seen. The quiet intensity of the man, the size of the charkha, our symbol of resistance, accentuated by being in the foreground, the light from a window at the back, everything coming together to create a portrait which is in itself the memory of the great man. Margaret Bourke-White, one of the greatest photographers of the time, had only three minutes on a day when Gandhi was on maun vrat (a vow of silence). The picture first appeared in *Life* magazine and since then has been published so often that it has become an icon in itself.

Photo courtesy Getty Images / Time Life Pictures

72

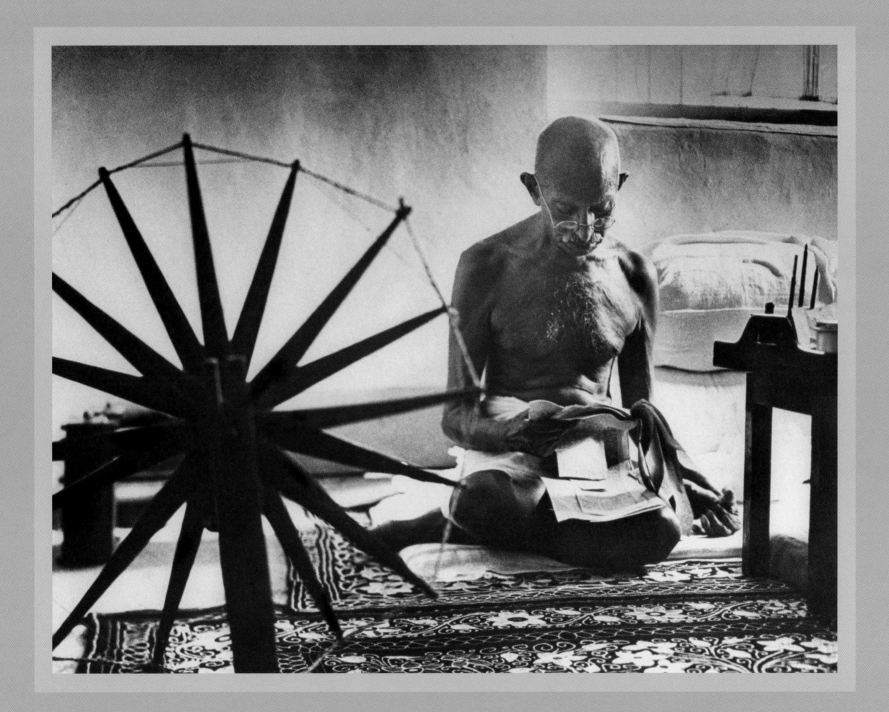

Gandhi during the satyagraha struggle in South Africa, 1913

Photo courtesy Gandhi Smriti

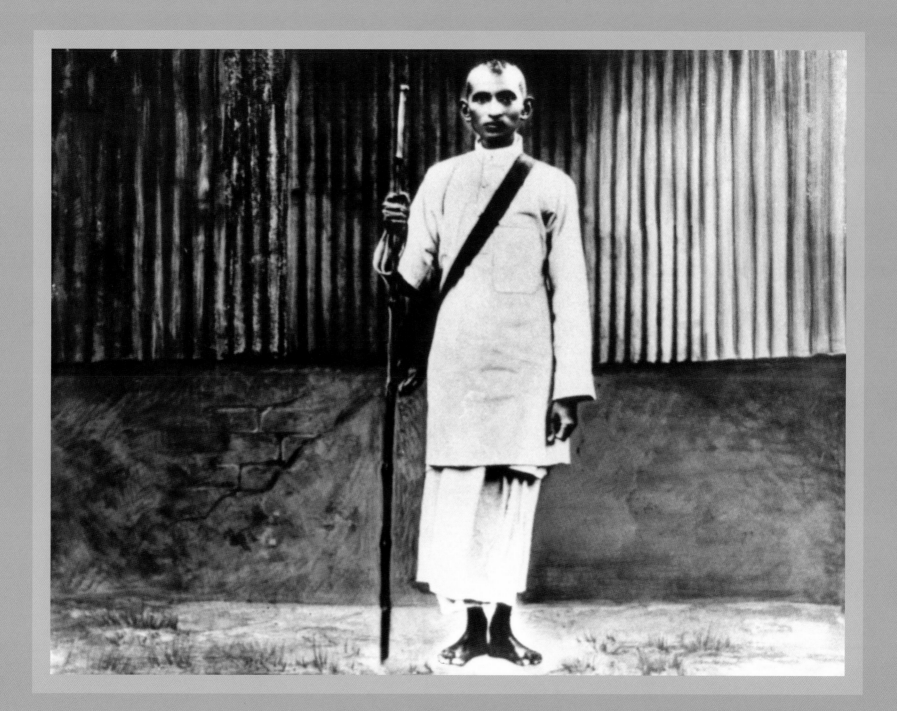

Gandhi with his followers during the Dandi march, 1930

To protest against the law that made it illegal for people to manufacture salt or collect it from its natural deposits at the coast, Gandhi and a large group of Satyagrahis embarked on a 320-kilometre march from Sabarmati Ashram to Dandi, a coastal town in Gujarat. They reached Dandi on 5 April 1930. Gandhi picked up salt from the seashore and urged all Indians to similarly flout the law. In its symbolism and the enormous popular support it gained, the Dandi march became perhaps the single most significant act of defiance against British rule in India.

Photo courtesy Gandhi Smriti

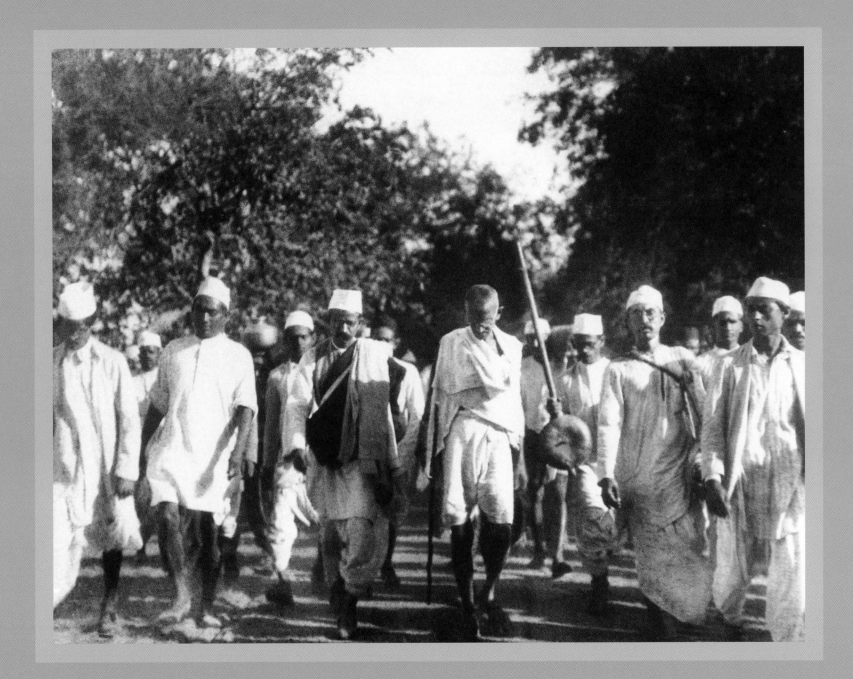

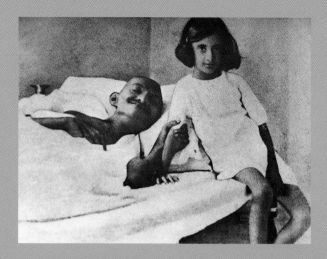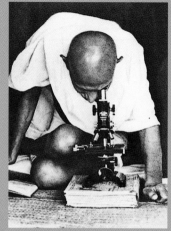

Gandhi walking with his two great-nieces and Khan Abdul Gaffar Khan, 1947

Gandhi's 'walking sticks', his two great-nieces Manu and Abha, were his constant companions during his last days. Also in the picture is Khan Abdul Gaffar Khan, the Pathan leader also known as Frontier Gandhi, who according to the Mahatma was the only other person in the country to have accepted non-violence as a creed.

Photo courtesy Gandhi Smriti

(*Top left*) Gandhi with six-year-old Indira Gandhi during his twenty-one-day fast undertaken as a penance for communal disturbance all over India, Delhi, 1924

Photo courtesy Gandhi Smriti

(*Top right*) Gandhi studies leprosy germs under a microscope at Sevagram Ashram, Wardha, 1940

Kanu Gandhi, Photo courtesy Gandhi Smriti

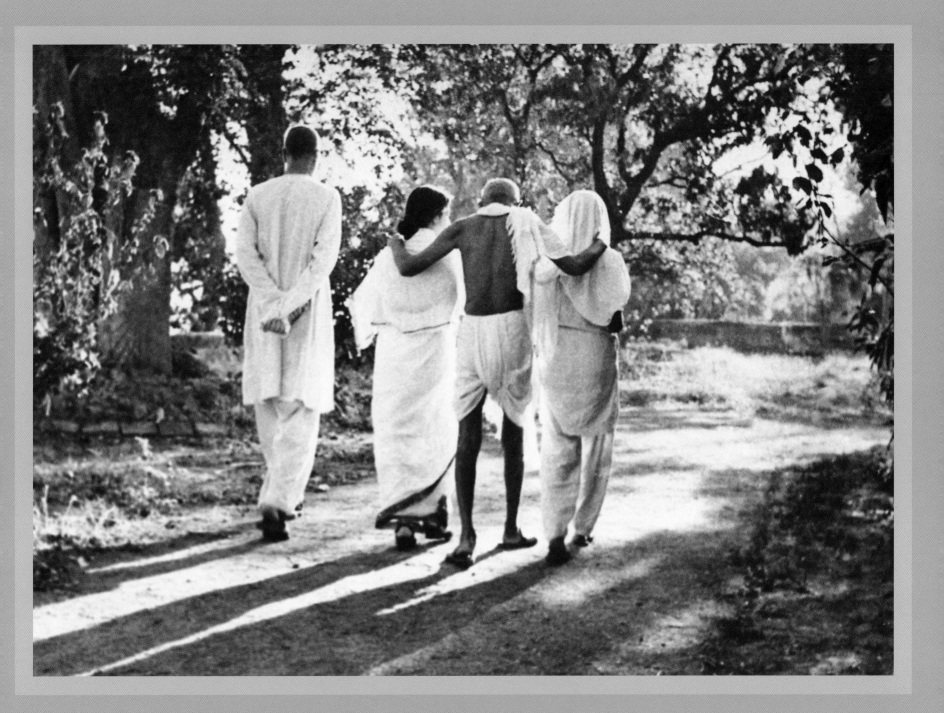

Max Desfor

Nehru and Gandhi, Bombay, 6 July 1946

Gandhi and Nehru, two towering figures of the freedom struggle, played a major part in shaping Indian nationalism and modern India. Though their views and hopes for India differed, the ascetic, traditionalist Gandhi and the suave, British-educated Nehru shared a special relationship.

Photo courtesy Associated Press / Max Desfor

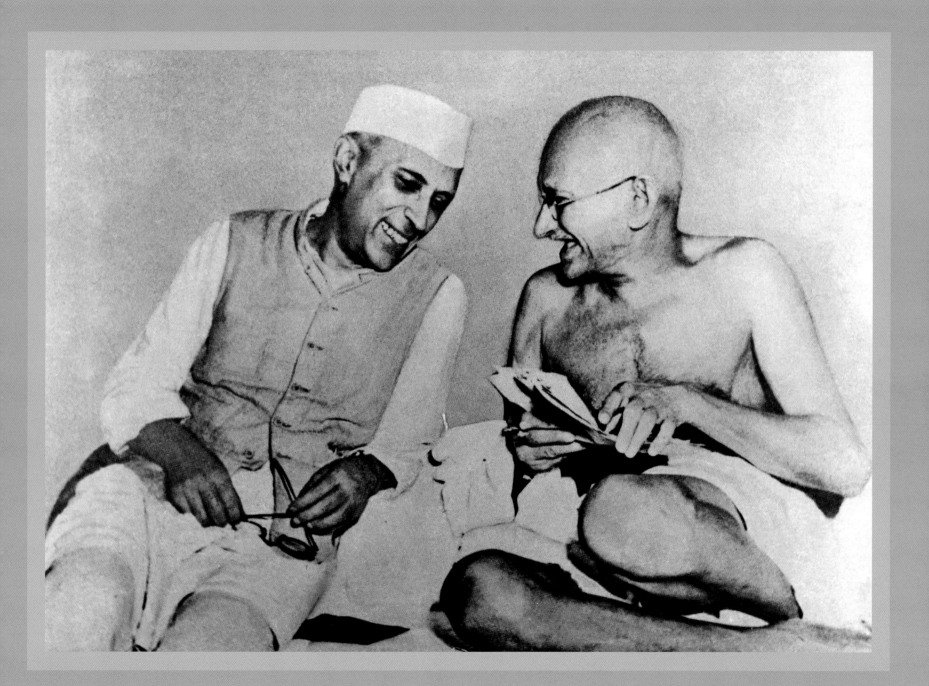

Portrait of Rabindranath Tagore

Poet, songwriter, playwright, novelist and painter, Rabindranath Tagore won the Nobel Prize for Literature in 1913. Tagore attained fame in the West with the translations of some of his poems and for the world he became the voice of India's spiritual heritage. In India, especially in Bengal, he became an institution in his own lifetime. This is the most famous picture of the man who composed India's national anthem.

Photo courtesy Photo Division

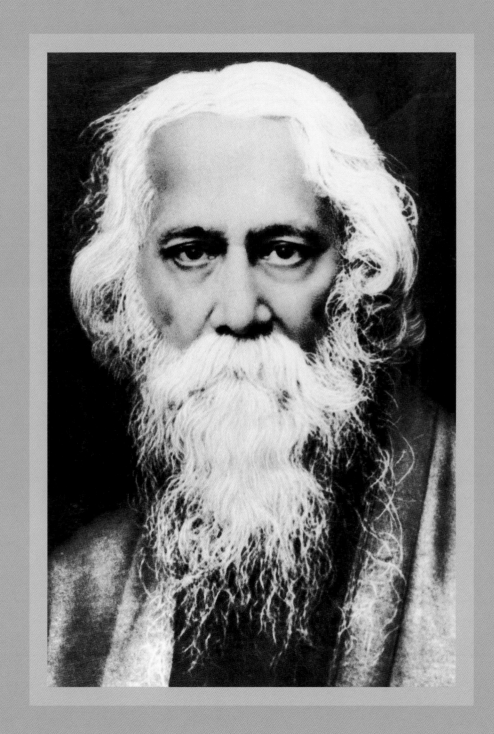

Portraits of Chandrashekhar Azad and Bhagat Singh

Most Indians have grown up with calendar-art images of Bhagat Singh and Chandrashekhar Azad, young revolutionaries who are among India's most popular and admired freedom fighters. Bhagat Singh was hanged to death by the British at the age of twenty-three, and Chandrashekhar Azad died in a gun battle with the British police. Few, however, have seen these original photographs on which the painted images and a whole folk culture are based.

Photos courtesy Photo Division

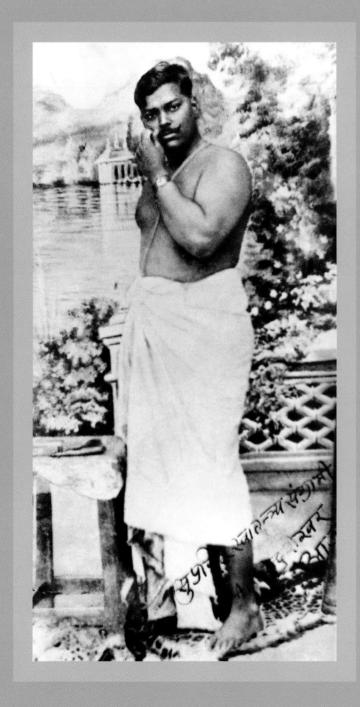

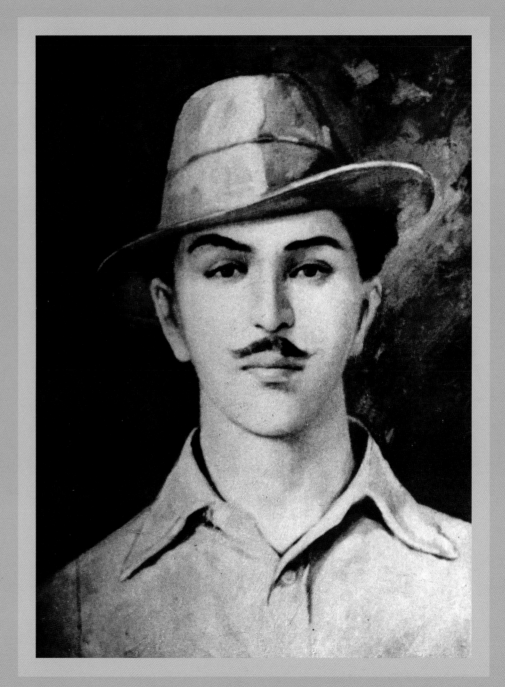

Subhash Chandra Bose with the Indian National Army

Along with Gandhi and Nehru, Netaji (The Leader), as Subhash Chandra Bose is popularly known, represents the Trinity in the pantheon of India's freedom fighters. His philosophy, though, differed radically from Gandhi's and Nehru's. He rejected the non-violent approach and went into exile to set up the Indian National Army (INA) to fight against British rule during the Second World War. In 1945, a plane believed to be carrying Bose among its passengers crashed near Japan, but his body was never found. It is a measure of the mystique associated with Netaji in India that many people believe he survived the crash and is still alive.

Photo courtesy Netaji Research Bureau

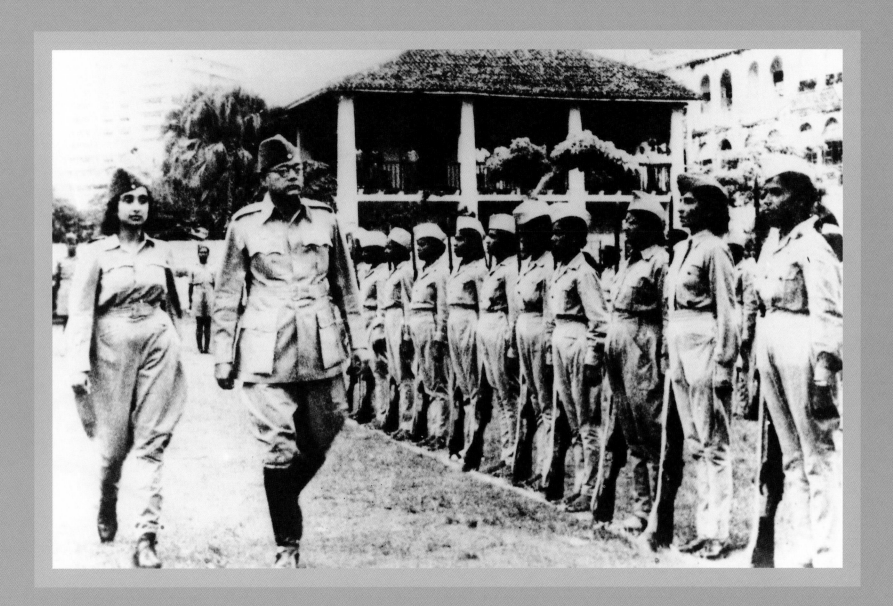

Homai Vyarawalla

Pandit Nehru is sworn in as independent India's first prime minister,
Delhi, 1947

Homai Vyarawalla, India's first woman photojournalist, captured several significant moments in India's
history, particularly around the time of Independence. This photograph is associated with the Transfer of
Power, a midnight ceremony on 14/15 August, in the Council Hall when Nehru made his famous 'Tryst
with destiny' speech and British rule in India formally ended.

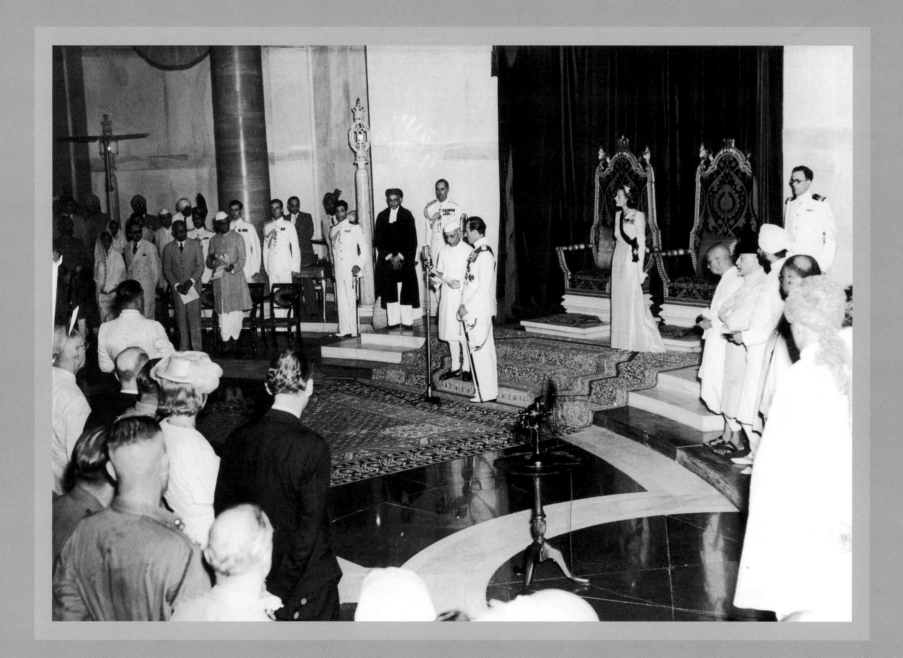

A refugee special train at Ambala railway station, 1947

As the British withdrew from India, the country was divided along religious lines, resulting in the creation of the new state of Pakistan, and perhaps the largest dislocation of populations in modern history. Communal riots broke out on both sides of the new border; hundreds of thousands of people lost their lives and millions were rendered homeless. Partition remains the most tragic and violent event in the history of the subcontinent, and the defining images of that turbulent period are pictures of trains packed and overflowing with refugees.

Photo courtesy Photo Division

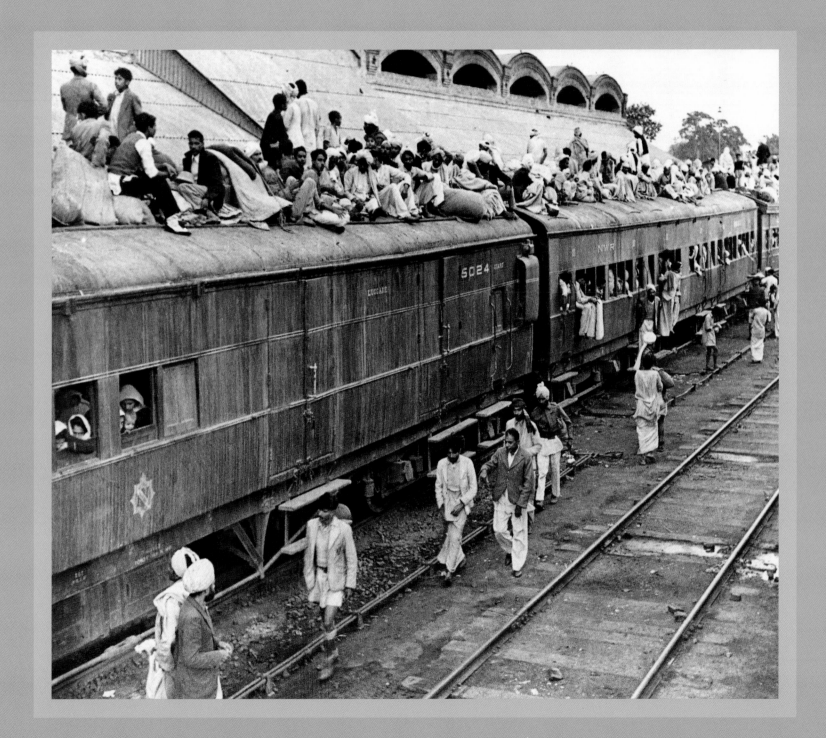

Henri Cartier-Bresson

Pandit Nehru announces Mahatma Gandhi's assassination at Tees January Marg, Delhi, 1948

'The light has gone out of our lives and there is darkness everywhere,' said Jawaharlal Nehru in an address to the nation minutes after Gandhi's assassination. 'The light has gone out, I said, and yet I was wrong. For the light that shone in this country was no ordinary light. In a thousand years that light will still be seen . . . the world will see it and it will give solace to innumerable hearts. For that light represented something more than the immediate present; it represented the living, the eternal truths, reminding us of the right path, drawing us from error, taking this ancient country to freedom.'

Photo copyright © Henri Cartier-Bresson / Magnum Photos

Henri Cartier-Bresson

Gandhi's funeral, Delhi, 1948

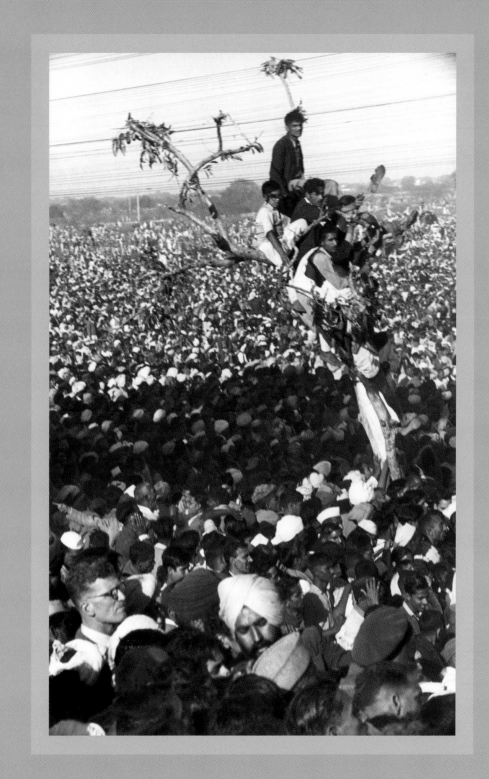

Chacha Nehru releases a white pigeon at a children's rally at the National Stadium on his birthday, Delhi, 1954

Jawaharlal Nehru, visionary statesman and first prime minister of independent India, was also known for his love of children. His easy and loving manner with children earned him the title chacha, or uncle. His birthday, 14 November, is celebrated in India as Children's Day.

Photo courtesy Photo Division

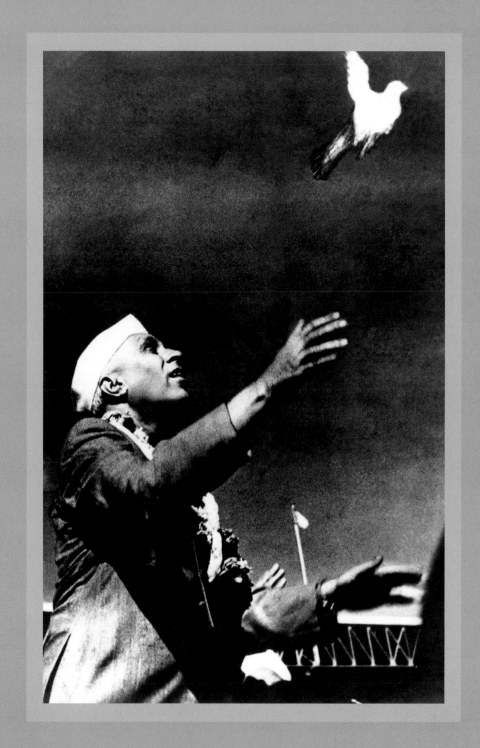

The Years of Freedom

It is now nearly six decades since that morning when the Union Jack came down, Nehru hoisted the Tricolour and grown men in the crowds milling around Red Fort wept tears of joy. What have we done with our freedom in these years?

Our achievements are many. Following the upheaval of Partition, we settled all our refugees without asking for assistance from any country or international agency. We have almost tripled our life expectancy, overcome killer epidemics, increased food production to a level where we routinely export surplus grains, and made great advances in industry and in space and information technology. Above all, we remain a democracy (the world's largest), and our media is as free as the freest in the world. But there is enough on the debit side to make us despair. Millions continue to live in extreme poverty, untouchability is still practised in several parts of the country, many of our politicians, bureaucrats and industrialists are appallingly corrupt, and religious fanaticism of every hue has found a home here.

It is a mixed scorecard, but there is reason for optimism. Though our diversity has periodically come under threat, it has survived and remains our greatest strength as a nation. While democracy has been abused and perverted in the country, it has also empowered Dalits and other poor and marginalized communities. Most significantly, tens of thousands of people no longer look to the government or self-styled leaders to do things for them but in their own way are doing their best for themselves as well as for their neighbours. They are everyday people—farmers, factory hands, social workers. Our soldiers, actors, sports stars and beauty queens may bring us some cheer every once in a while, but it is the courage and commitment of ordinary Indians that will give us the future we all deserve.

Raghu Rai

Prime Minister Indira Gandhi with her ministers at her office in Parliament House, Delhi, 1970

'This picture was taken while I was doing a photo feature on a day in the life of the prime minister for the *Junior Statesman*. I had been photographing Mrs Gandhi regularly on assignments, being chief photographer of the *Statesman* then, and had already got to know her well. The morning of the day this picture was taken, I was at Mrs Gandhi's home and she asked me to go to her office in the afternoon to photograph her. She was already at work when I arrived there. Her secretary took me in through the back door and this was the very first sight I saw—she was the lone woman in the room and there was no mistaking who the boss was. It was often said that Mrs Gandhi was the only man in her cabinet, and this picture shows exactly why. It came to symbolize the phenomenal power one woman had in our otherwise male-dominated society.'

100

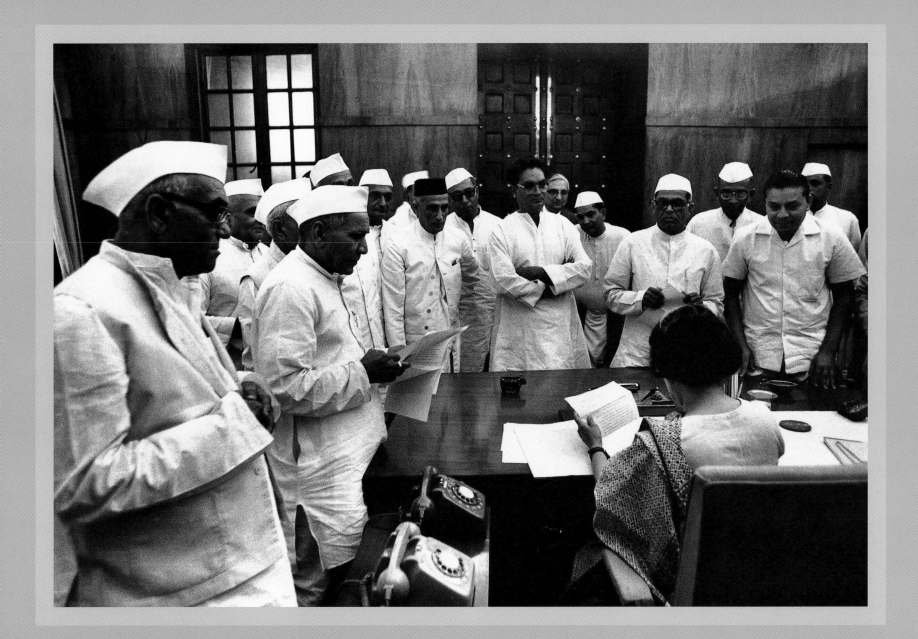

Kishor Parekh

Mukti Bahini guerrillas fighting on the streets of Dacca, December 1971

Parekh lay on his belly, caught in the crossfire, and shot this frame (and two more) using a wide-angle lens. The resulting picture, where the shoe looms large and almost has a character of its own, is regarded as one of the classics of Indian news photography.

Parekh did not, in fact, have any accreditation to officially cover the war. He was then based in Hong Kong, working as a picture editor with a group of South-East Asian publications that mainly did travel stories and had no interest in covering the Indo-Pak war. But Parekh's instincts told him he should be in East Pakistan (as Bangladesh was known before the war) to shoot the breaking story rather than work on some soft travel feature. He took the first flight out and without any official permission reached the border near Calcutta with a limited stock of black-and-white film. Once there, he jumped into an army helicopter carrying a press party to the scene of action. The officer escorting the press refused to leave with him on board, but Parekh was adamant: 'Shoot me right now, or take me with you,' he said. The officer eventually gave in, but made it clear that he would take no responsibility for Parekh in the war zone. Once inside East Pakistan, Parekh struck out on his own, trekking and hitch-hiking in trucks to areas where the fighting was at its fiercest. From 8 to 17 December 1971, he recorded the brutality of the war and the traumatic birth of a new nation. His pictures, which he put together in the book *Bangladesh: A Brutal Birth* (1971), are still remembered and talked about not just for their photographic finesse but also for their emotional content and power to move. Parekh is often credited with having given the man behind the camera a status unknown in Indian photojournalism till then.

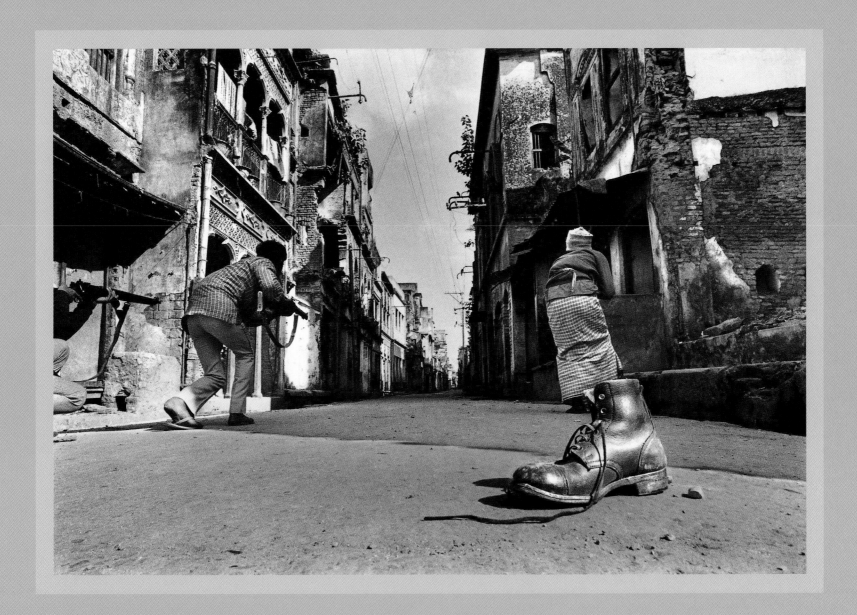

Surrender of the Pakistani Army: General Niazi signing the papers, Dacca, 1971

India and Pakistan went to war in late November 1971 over East Pakistan. It was a short war, and ended with Lt Gen. A.A.K. Niazi, the Army Commander of all Pakistani forces in the area, signing the surrender document at the Dacca racecourse on 16 December 1971. Lt Gen. Jagjit Singh Aurora, the GOC in C, Eastern Army Command, accepted the surrender on India's behalf. Gen. Niazi took out his pistol, removed the bullets and handed over the firearm to Gen. Aurora. 'With that he has handed over East Pakistan as free Bangladesh,' remarked an officer on the scene.

Photo courtesy DPR Photo Division / Ministry of Defence

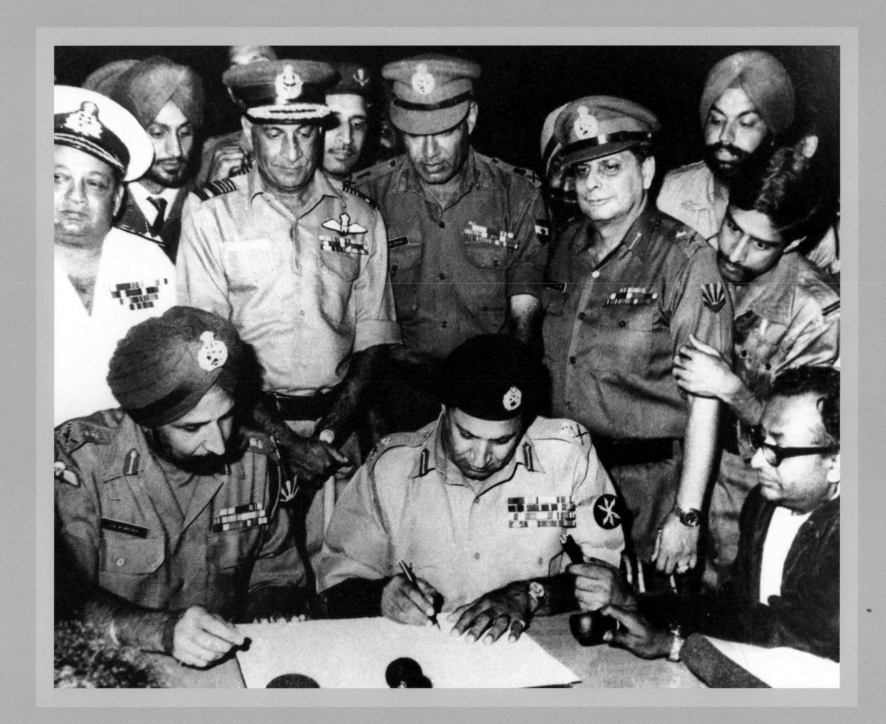

Raghu Rai

Sweeper, Indira Gandhi election poster and family planning sign, Delhi, 1977

'The general elections had been declared and I would go to all the political rallies to photograph them. This was just after the end of the Emergency declared by Mrs Gandhi in 1975, during which no political pictures were being taken and my paper, *The Statesman*, would routinely leave censored pictures and stories as blank spaces in the daily edition as protest. The Janata Party had held an election rally at the Ramlila grounds where huge crowds had turned up in support. Mrs Gandhi responded with an impressive rally of her own, but it was widely believed that petty inducements and threats had been used to get the crowds there. I was present at both these rallies. When I returned to the office after Mrs Gandhi's rally, my editor, Kuldip Nayar, who trusted my instincts, asked me for my impression of it. I remember telling him that the essence of Mrs Gandhi's message to the crowd was (in words that I made up) *"Bhaiyon aur bahenon, aap mujhe apna keemtee vote dein . . . nahin to mein chheen loongi"* (Brothers and sisters, give me your precious votes . . . or I will snatch them away from you). In my mind I was already sure that she had lost the election.

'Late on polling day, I came upon this scene on the road leading from Daryaganj to Jama Masjid—an old man, who perhaps had nothing to do with politics, collecting torn election posters of Mrs Gandhi under a huge family planning slogan (which had come to be identified with Sanjay Gandhi's hated compulsory sterilization programme) painted on the wall. Back in office, I made a print of this picture and took it to Kuldip Nayar and told him that this was the perfect picture for page one. Though Kuldip Nayar liked the image, he did not want to use it because he thought it was premature. I argued with him, and finally walked away angry and upset, vowing never to return. The next day I did not go to office. By late afternoon, when it started becoming clear that Mrs Gandhi was losing, Kuldip Nayar rang me up, asking me to come back and give in the picture. The *Statesman* published the photo across six columns, without a caption, with just the byline, and it came to be regarded as a photo-editorial.'

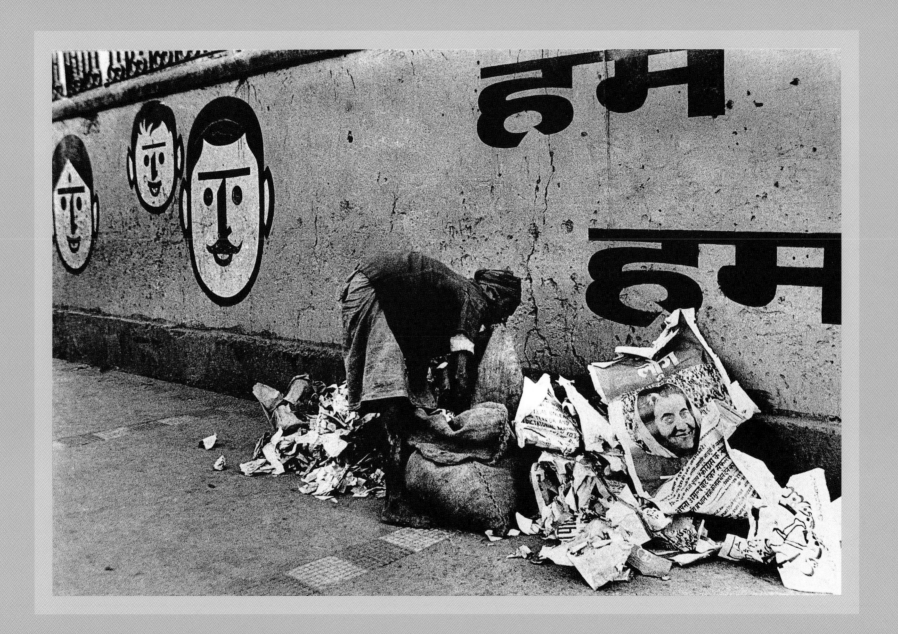

Raghu Rai

Rajiv Gandhi and his family at Indira's funeral, Delhi, 1984

A day after Indira Gandhi said, 'Even if I died in the service of the nation, I would be proud of it. Every drop of my blood . . . will contribute to the growth of this nation and make it strong and dynamic,' she was assassinated by two of her bodyguards. Even as the nation mourned, the Congress Party turned to Indira's son Rajiv and he took over as prime minister that very night. On 3 November dignitaries from all over the world assembled for her funeral at Shakti Sthal.

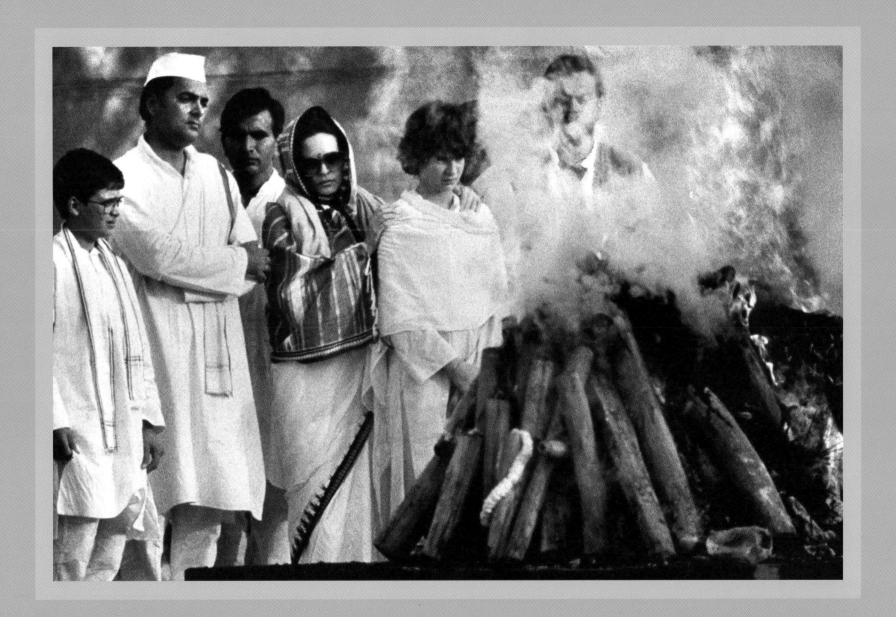

Raghu Rai

Burial of an unknown child, a victim of the Bhopal gas tragedy, 1984

'As soon as we journalists and photographers got off the plane in Bhopal the morning after the gas leak that killed close to 15,000, we rushed around the city—almost like vultures, I feel now—often bumping into each other, asking over and over again, "Where are the bodies?" Then we heard that Mother Teresa would be visiting the Hamidia hospital, and we all rushed there. The hospital was overflowing with the sick and dying—they were on the beds, on the floor, lying in the corridors; there wasn't even place to walk. Mother arrived, and we photographers pushed and shoved each other, even stepped on the victims, just to get a picture of her with them. Only when Mother left abruptly, saddened by our behaviour, did I realize how insensitive we were being.

'But this was a disaster of epic proportions, and the story had to be told. So we went back looking for bodies. Mass cremations and burials were taking place all over the city. We came upon this site hurriedly designated as the burial ground for Muslim victims. Due to lack of space, three-tier graves were being dug, like long trenches. One row of bodies would be laid down, some mud poured over them, and then another row would be laid on top. When we arrived—there were three of us photographers—this dead child was being covered with mud. As we stood there, watching, the old man who was performing the burial brushed away the mud from the gentle face, almost as if to make us understand the true extent of the horror.

'Perhaps because I was acutely aware of Mother Teresa's reaction to our behavior earlier in the day, I felt the pain and bewilderment that we saw in the child's eyes. The caress of that hand wiping the mud and dirt from his face became an expression of our collective grief.'

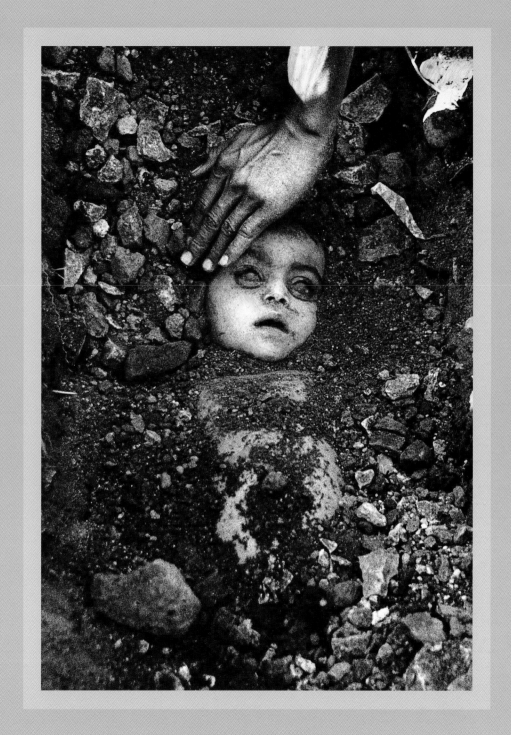

Raghu Rai

Raman Bind, a victim of the Bhagalpur blindings, 1980

'In 1979-80, the police in Bhagalpur, Bihar, dispensed immediate and medieval justice by blinding thirty-one prisoners in their custody. They used bicycle wheel spokes and acid. The country was shocked by the news, though in Bhagalpur citizens applauded their policemen. In the end a few policemen were suspended, the victims went back to their obscure lives and we all forgot about the incident. Only a few images remain, like this close-up of one of the prisoners, Raman Bind, who was brought for treatment to Delhi, to remind us of the kind of police brutality that still continues in our country.'

Photo courtesy India Today

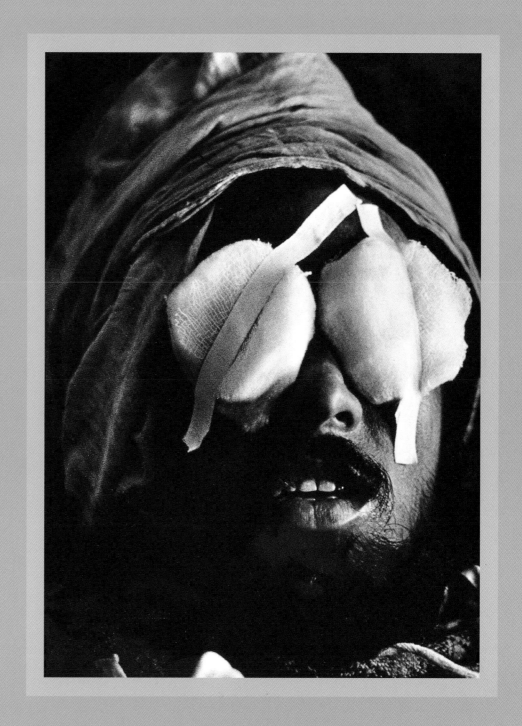

D. Ravinder Reddy

Dead child in the rubble of his home, Kilari, Latur, 1993

'The earthquake in Latur district, Maharashtra, on 30 September 1993 was among the worst natural disasters of the twentieth century. I had returned from an outstation assignment only the previous night and was so fast asleep in my Hyderabad apartment that I did not wake up when the tremors were felt in the city. In the morning I learnt that a massive earthquake had rocked Maharashtra, particularly the areas bordering Andhra Pradesh. I made enquiries and was told that the epicentre was in a village called Kilari, more than 300 kilometres from Hyderabad. As there was no time to arrange for transport, I set out for Kilari on my motorbike and reached the village at night. I slept amidst the rubble and stench. What I saw in the morning was a ghastly scene. But for a few people who were still alive, Kilari was a virtual graveyard. I was there the whole day, recording the aftermath of nature's fury. This picture of a child making a futile attempt to come out of the rubble was the last photograph I took in Kilari. It became the one by which most people remembered the Latur earthquake.'

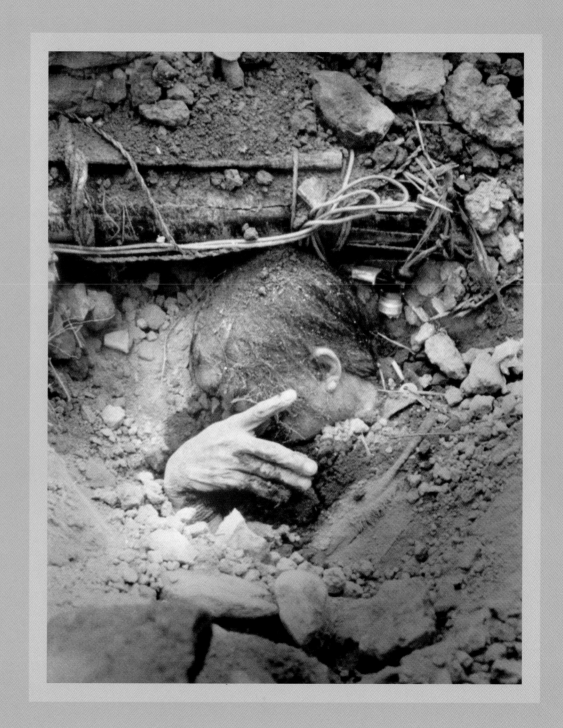

Raghu Rai

Mother Teresa, Nirmal Hriday, Calcutta, 1986

'Mother Teresa has been the greatest influence on my life. She had the ability to restore you to yourself. She was always there for you, one hundred per cent. She made you understand that to be honest is to make yourself available at all times and unconditionally. It is this selfless energy that can connect you to the Supernatural, to God, or whatever name you might want to give that one Supreme Force. I saw this each time Mother went into prayer: because of her purity and commitment to serve, to give, she would be connected like no other person I know.

'This image was made one evening at Nirmal Hriday, the home for the dying and the destitute in Calcutta. When it was prayer time, Mother simply knelt on the floor where she was working among the sick and the dying, and prayed. The connection was made, and I felt His presence.'

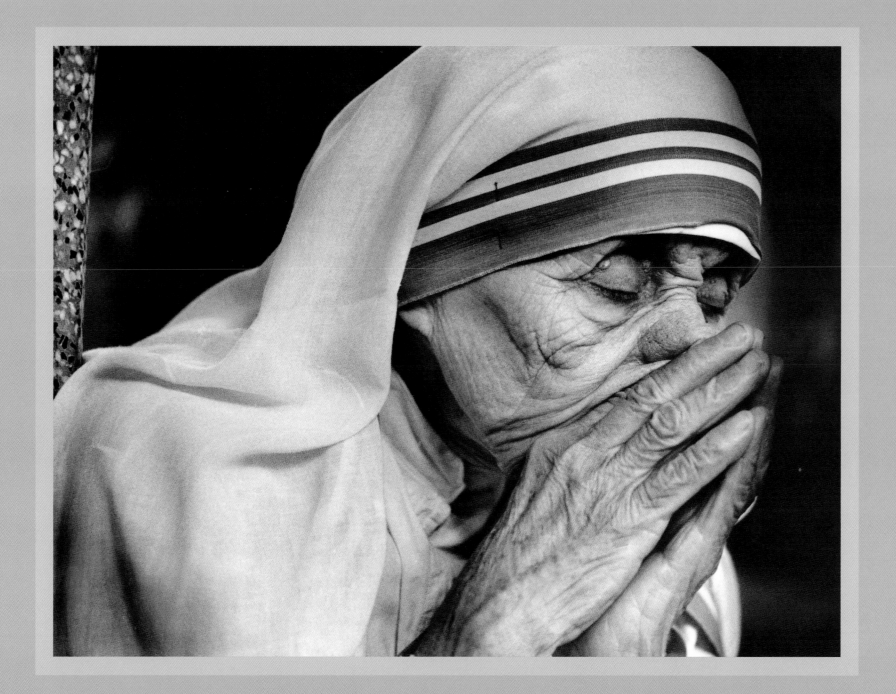

Sondeep Shankar

Bandit Queen Phoolan Devi surrenders, Bhind, Madhya Pradesh, 1983

'Phoolan Devi had been written about in newspapers and magazines for almost two years without any newsperson actually having met her. She was already a legend, portrayed as the Bandit Queen, Dasyu Sundari and Mistress of Murder. But when she came out in the open to surrender, on 12 February 1983, she looked hunger-stricken and was ill-tempered, hitting cameramen and abusing journalists. Travelling in the bus that took her to the surrender site, I managed to establish a rapport with Phoolan and was able to take this photograph of her greeting the 7000-odd villagers who had come to catch a glimpse of the legend. It was the only photograph that came anywhere close to the popular image that had been created of her. Which is why it has endured.'

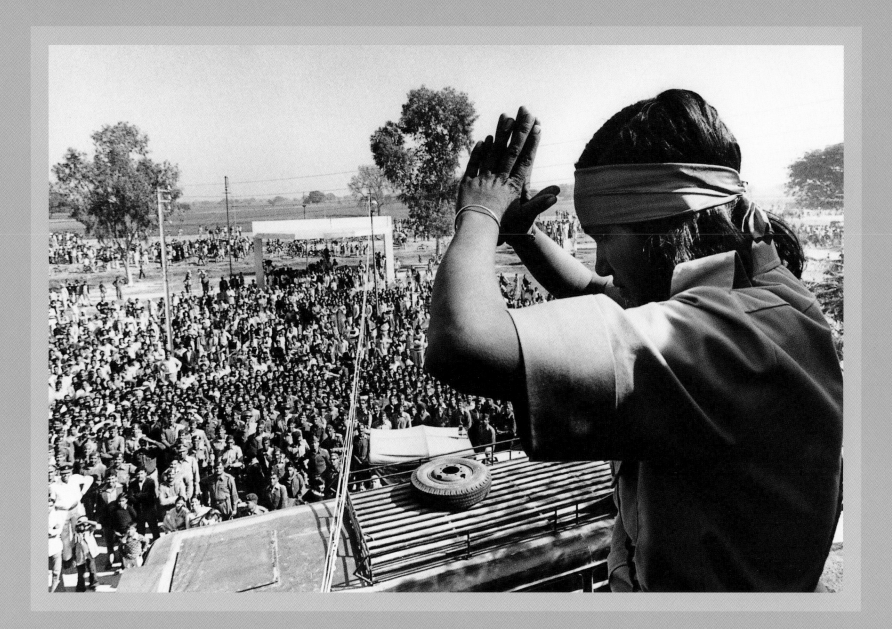

Three sisters commit suicide, Kanpur, 1988

The issue of dowry became the rallying point for the women's movement in India in the 1980s. In 1987 alone there were 1319 dowry deaths registered. This shocking image of the three Sahu sisters who hanged themselves because their father was too poor to arrange for their dowry has come to symbolize this malaise in our society.

Photo courtesy Outlook

Photomontage of Roop Kanwar committing sati, Deorala, 1987

On 4 September 1987, Roop Kanwar, an eighteen-year-old Rajput bride, committed sati in the village of Deorala, Rajasthan. While it created a storm across the country, in Deorala the faithful ruled, with support from influential sections of Rajasthan's society. Roop Kanwar's family and the entire village deified her. The spot of her death was immediately consecrated. Thousands of people descended on the village for 'darshan' of the Sati-Mata and this crude cut-and-paste postcard was sold in the thousands. Kitsch photographic art rode on religious sentiment, giving this image a life of its own.

Photo courtesy Outlook

Jay Ullal

Bhagwan Rajneesh touches one of his ecstatic foreign disciples, Pune, 1976

Over three decades ago, Bhagwan Rajneesh, the charismatic godman and religious philosopher later known as Osho, captured the imagination of Westerners and some Indians with his radical, made-easy spirituality. The mid-1970s was the golden phase of his career, when he set up a commune in Pune, almost a miniature town with entry limited strictly to his followers, called sanyasins. Tales of the good life and easy sex in the commune received as much publicity as Rajneesh's lifestyle and teachings.

Jay Ullal gained the confidence of the 'Bhagwan' through some of his disciples, but was allowed into the commune with his camera only after he agreed to wear the customary mala and robes and became a sanyasin. For six weeks he lived as one of Rajneesh's disciples—he shed his name and came to be called Swami Jayananda. What emerged was an amazing document of life in the commune, with some very explicit pictures. Ullal's images summed up the quest for peace, love and joy that began with the hippy years of the late 1960s in the West, reaching its height in the 1970s and 1980s, and coincided with the rise of a number of Indian godmen.

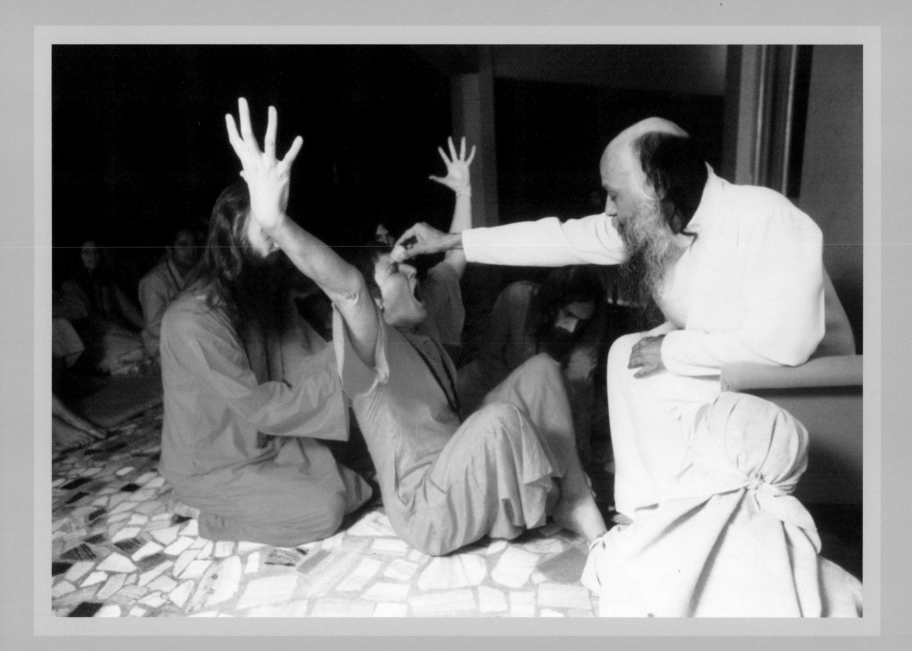

Rajesh Bedi

Tiger in the water, Kanha, early 1970s

Among the most celebrated wildlife photographers and film-makers in India, Rajesh Bedi and his brother Naresh have captured on film rare footage of elephants, man-eating tigers of the Sunderbans and the snow leopard for over three decades. Their films have been telecast on major television networks around the world.

To protect the dwindling number of tigers, the Government of India launched Project Tiger in 1972 and by 2002 the tiger population had almost doubled to 3600, thanks to the efforts of environmentalists and conservationists. Images such as these helped create awareness about the need to protect and preserve our wildlife.

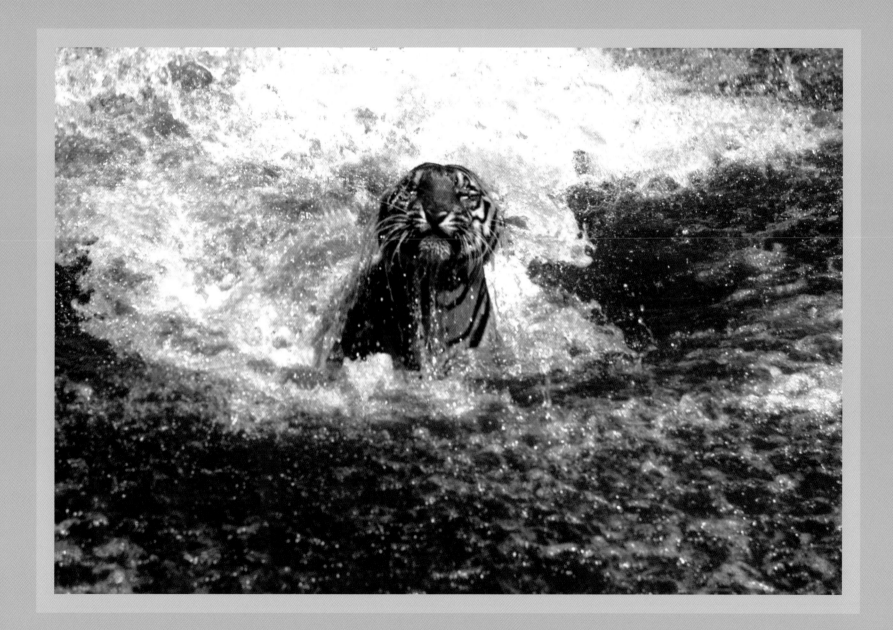

Sanjeev Saith

Water lilies, Delhi, 1996

'In August 1996, Arundhati Roy asked me to shoot a photograph that could be used as the cover of her forthcoming novel, *The God of Small Things*. She wished that the image be of the surface of water and that it evoke the depth and complexity of the book. We planned to shoot on the Meenachal river near Ayemenem, Kerala, where some of the most moving passages of her narrative are located. Before we left for the river, we spent an hour together at a pond in Delhi, looking at water, looking into it, so that she may see what I might see. I took some pictures. We spent the best part of the next week on a small vallam, quietly adrift on the Meenachal. I learnt a Malayalam song; the idea of a new literary imprint came to be; I exposed 600 frames. Roy flew to London to work with a designer, shortlisted photographs in hand. In the end, the chosen image was from the pond back in Delhi. It is a beautiful, decorative image. "Haunting," say some who ask for prints. Carried by fine literature, it has found meaning, entering homes across the world, touching the minds of millions as the face of India's best-known novel.'

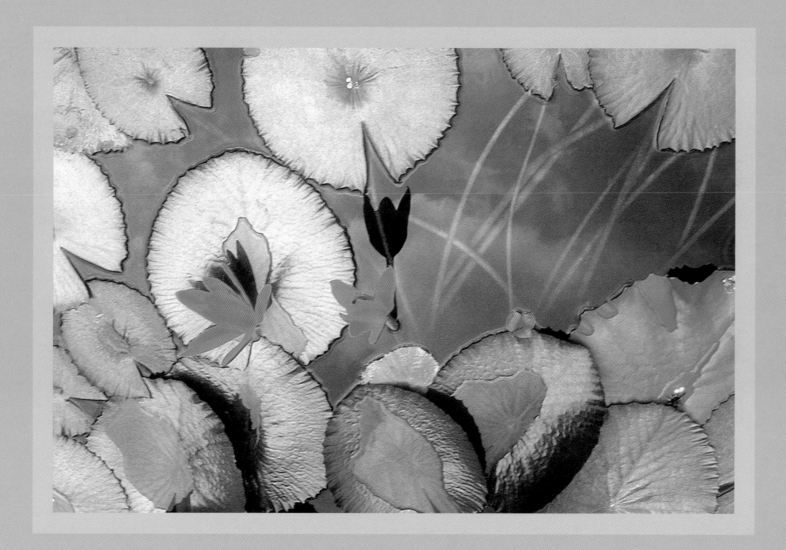

The first kiss on the Indian screen: Devika Rani and Himanshu Rai in
Karma, 1933

Considering that even today leading actresses in India are reluctant to kiss on-screen, it is no surprise
that this still has attained cult status. Echoing the strong, liberal and iconoclastic real-life persona of
Devika Rani, the screen goddess of her era, this classic still places the woman in a rare position of sexual
dominance. Despite this 'bold' beginning, for decades portrayal of sex in mainstream cinema was limited
to flowers and bees substituting for the protagonists during scenes of serious physical intimacy.

Photo courtesy Firoze Rangoonwalla

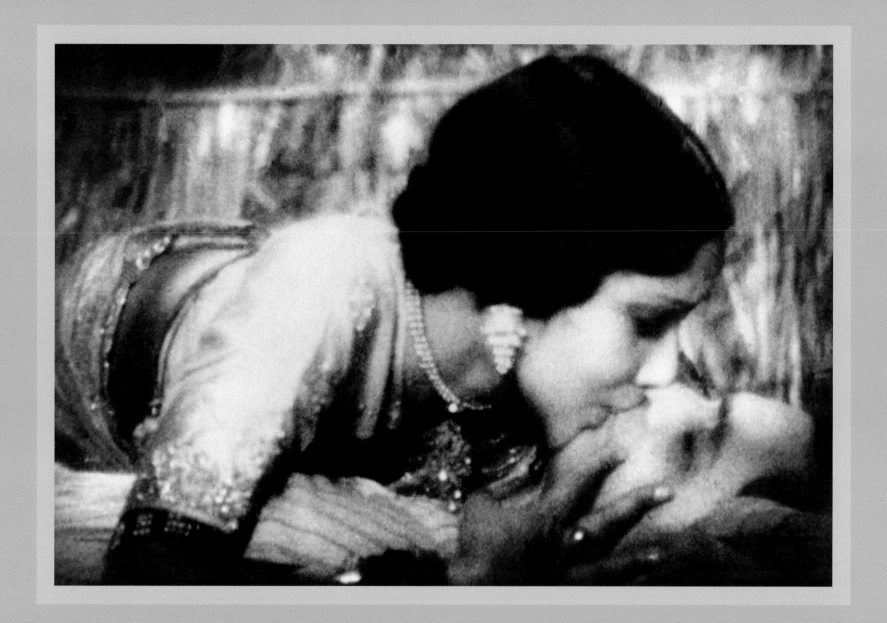

Nargis and Raj Kapoor in *Shri 420*, 1955

This still, part of a song sequence from the 1950s' classic starring Nargis and Raj Kapoor, is among the most enduring and popular images of Indian cinema. Both actors were at the peak of their careers and the on-screen chemistry between them, aided by conjectures about their off-screen relationship, was unlike anything Indian audiences had seen till then, or have since. The image also owes its tremendous appeal to the lyrics of the song—which are about first love—and the expert use of the spirit and feel of the monsoon, a very special season in the subcontinent.

Photo courtesy Kamat Foto Flash

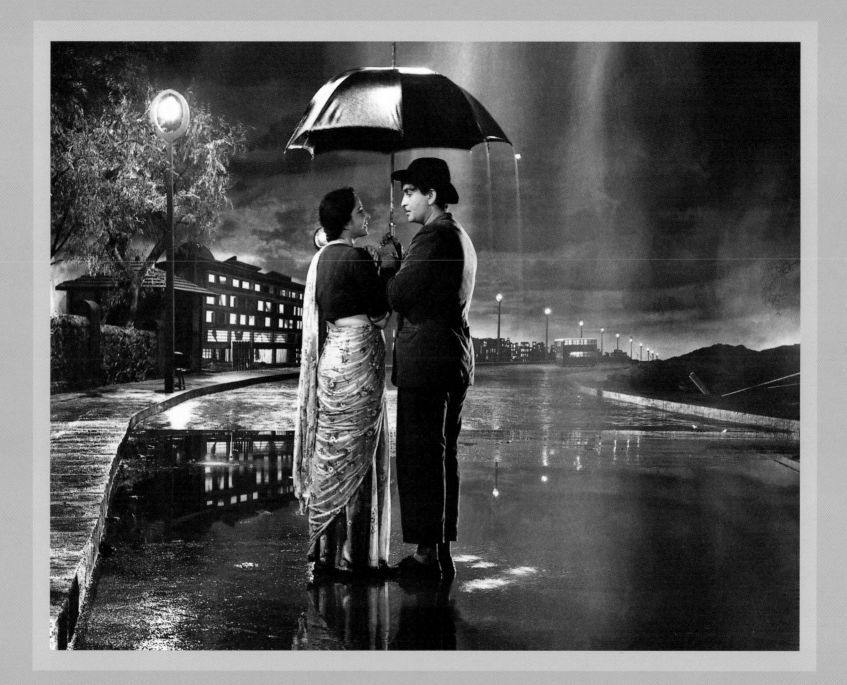

Madhubala portrait, 1960

Sold as a poster on the streets of India for over four decades now (along with all the other popular images: gods, babies, buxom pin-up girls, fast cars and serene landscapes), printed and reprinted often in newspapers and magazines, this publicity still of Madhubala from the film *Barsaat ki Raat* is perhaps the most loved and famous portrait of an Indian actress ever.

Photo courtesy Kamat Foto Flash

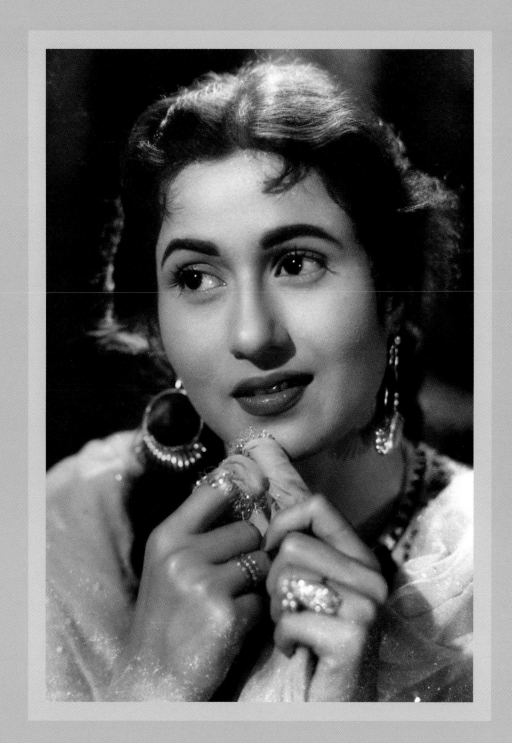

Guru Dutt and Waheeda Rehman in the poster of *Pyaasa*, 1957

The poet and the muse. The sensitive and disillusioned poet who will find his soulmate only in the lowly prostitute is another oft-used theme in Indian cinema, nowhere expressed as eloquently as in the Hindi film *Pyaasa*. The prostitute has her eyes closed, face turned upwards in symbolic prayer to her 'god', the enlightened poet, who in liberating her will find his own freedom. Guru Dutt's much written about personal anguish as an artist and the rumours of his off-screen relationship with Waheeda Rehman add another dimension to the image.

Photo courtesy Kamat Foto Flash

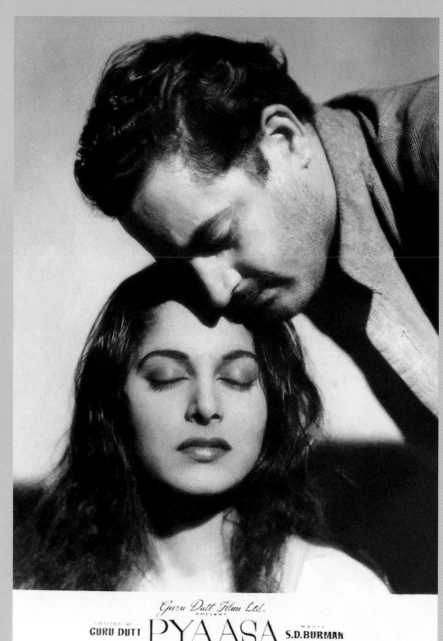

Publicity still from *Hum Aapke Hain Kaun*, 1994

Hum Aapke Hai Kaun, a feel-good three-hour extravaganza described by many critics as the definitive marriage video, broke all records at the box office, running to packed houses week after week. Full of song-and-dance routines, the movie depicted the easy bonhomie of an enormous joint family, entirely free of conflict. It was extreme conservatism packaged in designer clothes and elaborate sets that showcased the dream of the new Indian middle class.

Photo courtesy Rajshri Productions

Amitabh Bachchan in *Deewar*, 1975

India in the early 1970s was a nation in the grip of strong but barely articulated socio-political discontent resulting from corruption, unemployment and inflation; there was no space here for the hope and idealism of the newly independent India of the 1950s and early 1960s. Popular media, especially cinema, could not fail to reflect this. With fire in his eyes and ire in his soul, the persona of 'the angry young man', perfected by Amitabh Bachchan in films like *Deewar*, mirrored the disillusionment of the masses, and held out the promise of instant justice, even if it meant taking on and subverting the establishment. Lanky, brooding and angst-ridden, Bachchan was the antithesis of the traditional singing and dancing screen hero. One look at him and you knew: there was nothing much in life to sing and dance about. The angry young man remained the defining character of Hindi cinema till the mid 1980s, and made Bachchan a superstar.

Photo courtesy Trimurti Films

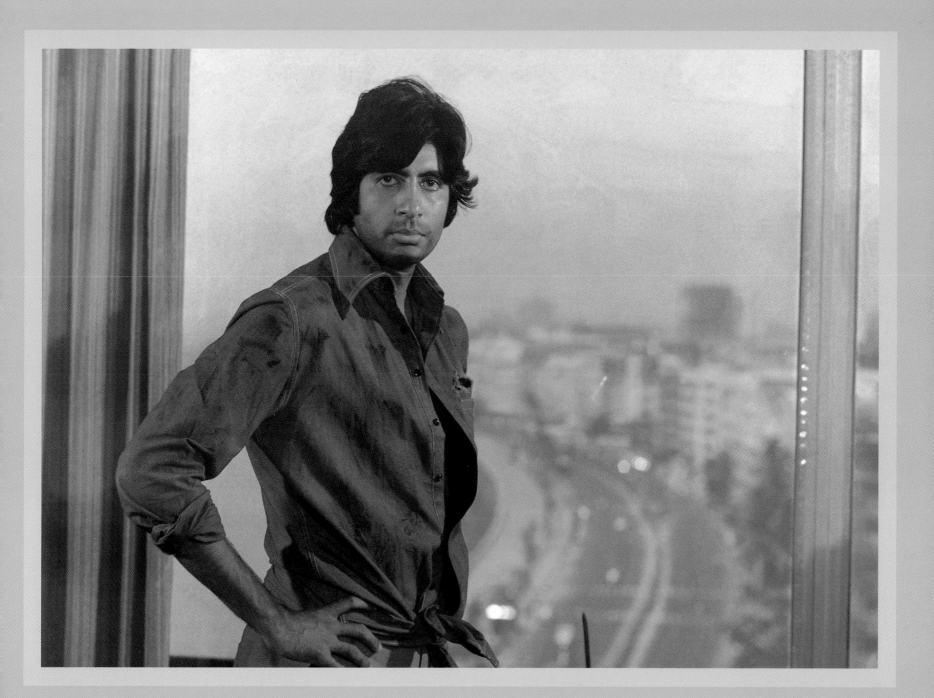

Still from the tele-serial *Ramayan, 1986*

Sunday mornings would never be the same after Ramanand Sagar brought the religious epic *Ramayana* into the drawing rooms of India. Work came to a standstill, streets wore a deserted look and there were reports of families lighting incense sticks before their television sets during the one-hour episodes. As the country was swept by a religious fervour, the stars of the serial briefly attained iconic status, even winning parliamentary elections on the strength of their on-screen image.

Photo courtesy Ramanand Sagar Productions

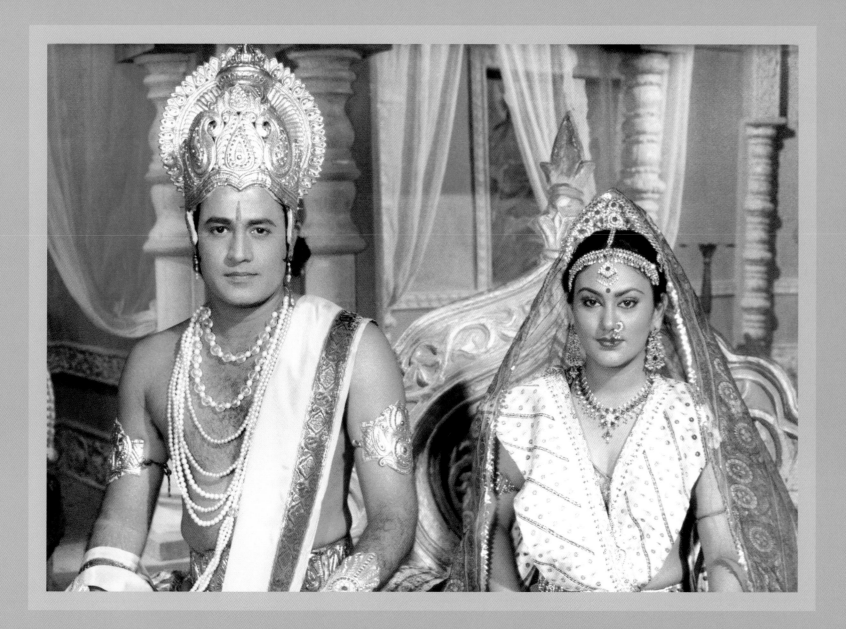

Romeo Gacad

Winner Miss India, Sushmita Sen (L), looks stunned while Miss Colombia Carolina Gómez Correa shouts with joy as Sen is announced the new Miss Universe 1994, Manila, 1994

Months of gruelling training and discipline finally paid off when Sushmita Sen was crowned Miss Universe 1994, on 21 May 1994, heralding the arrival of Indian beauties on the world stage. The year also saw Aishwarya Rai become Miss World. Over the next six years it poured beauty queens: India had another Miss Universe and three more Miss Worlds.

The opening up of India's markets in the early 1990s not only brought about economic liberalization but also spurred cultural engagement with the Western world. The fashion industry and the glamour associated with it became accessible to the urban Indian youth who could now dream of careers beyond the traditional ones like medicine and engineering.

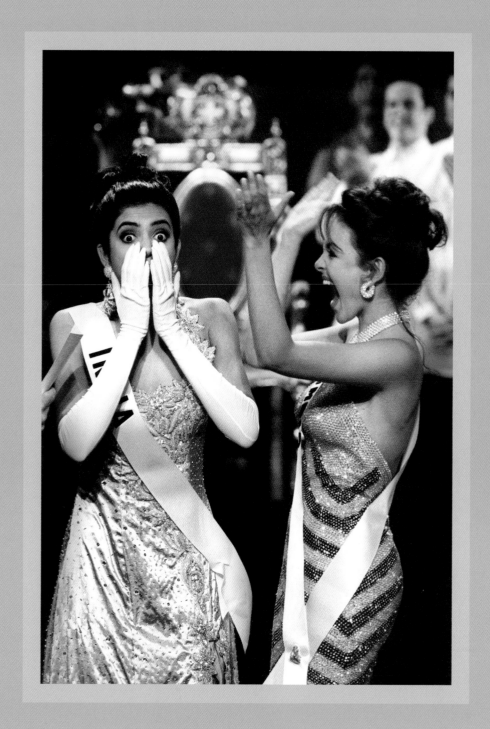

Dayanita Singh

Samara Chopra and her best friend Pooja Mukherjee, New Delhi, 1997

'I had been photographing Samara since she was three years old, well before the time I thought of photography as a profession. In fact when I did decide to shift the focus of my photojournalistic work to more formal family portraits, I started with the Chopra family. I started to enjoy the collaboration with the families and to partake in the playing out of the family fantasy. One day Ashwini (Samara's father) asked if we could make a portrait of the whole family in bed on a Sunday morning—Ashwini himself, his father reading the paper, Sarina, his wife, smoking a cigarette, the kids lying among them, and Deen Dayal (the family retainer) with the tea tray.

'This photograph was another one in the Chopra family series, except this time the family was Samara and her best friend Pooja. They decided to wear similar outfits, and we had many dress and location changes during the shoot. Then the doorbell rang, and Deen Dayal walked right through the frame, turned and looked shocked at how the girls had grown. His presence really made the photograph.'

146

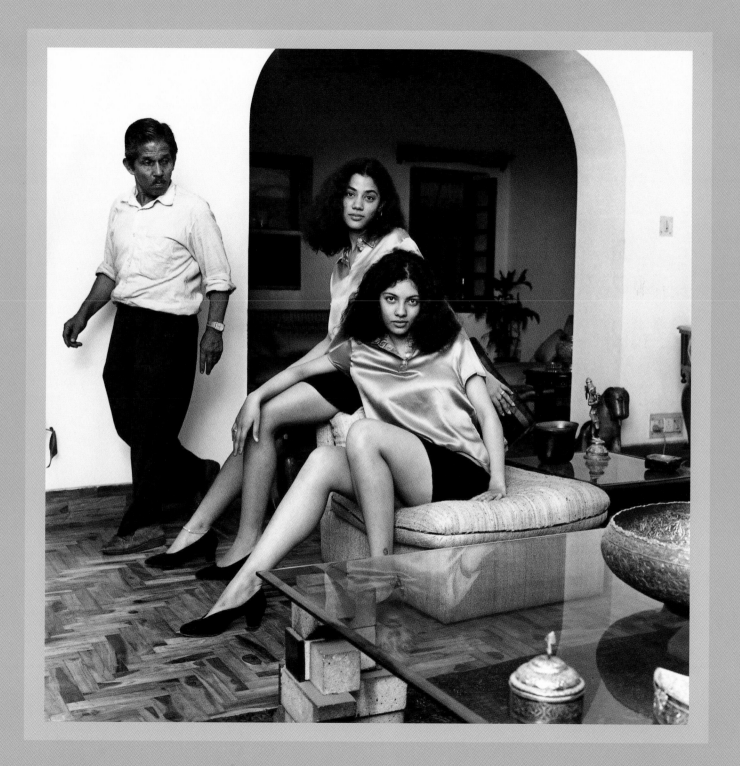

Sachin Tendulkar aged five, Bombay

With more international centuries to his name than anyone else in the history of cricket, Sachin
Tendulkar enjoys demi-god status in India, where the game is a religion. For sheer technical brilliance,
prodigious run scoring and all-round consistency, Tendulkar is unmatched in contemporary cricket and is
widely hailed as the greatest batsman to have taken the field since Don Bradman.

Photo courtesy Tendulkar Family Album

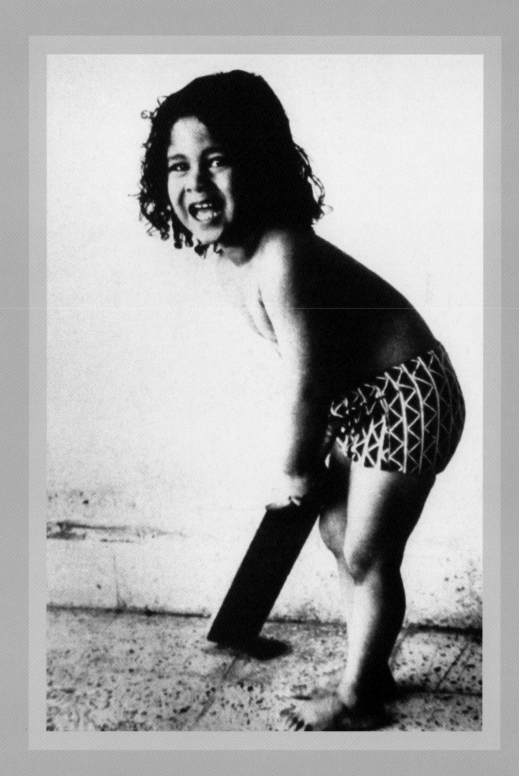

Patrick Eagar

Kapil Dev and Mohinder Amarnath at Lords after India's win at the
Cricket World Cup, London, 1983

The unimaginable had happened—minnows India defeated two-time world champions West Indies in the
finals of the Prudential World Cup. With this low-scoring match—the West Indies collapsed at 140 runs
chasing a modest target of 184—the Indian team led by Kapil Dev, arguably India's most charismatic
captain ever, changed the history of one-day cricket.

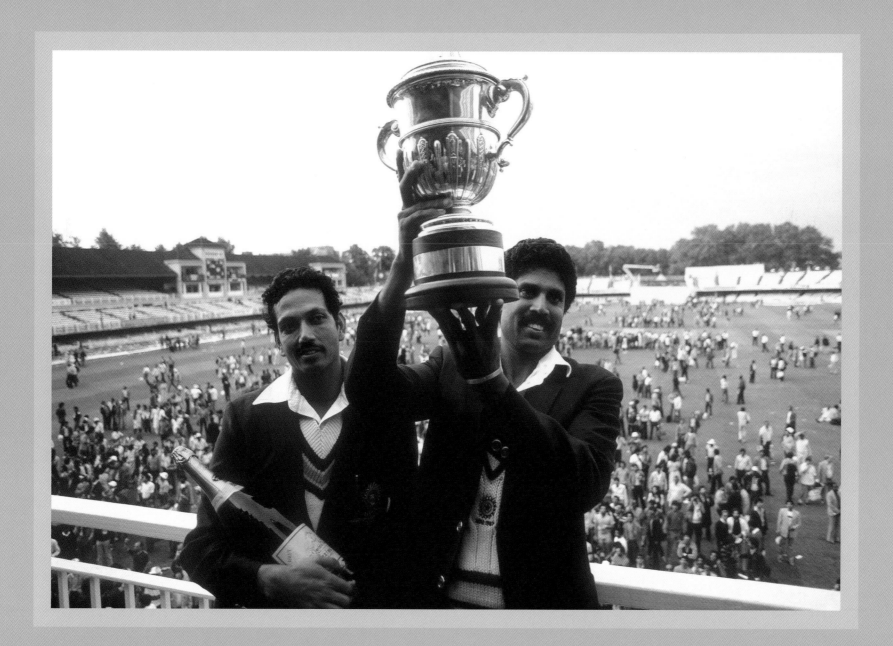

Raveendran

Rajeev Goswami burning, Delhi, 1990

'During the agitation against the implementation of the Mandal Commission Report (which recommended reservations in government jobs for the backward castes), I used to cover student protests in Delhi. On 19 September 1990, I received information that hundreds of college students were planning to protest in front of Deshbandhu College in Kalkaji. I was among the twenty or so press photographers who reached the spot around 9.30 that morning. About forty-five minutes later a large group of students, both boys and girls, gathered in the middle of the road outside the college, lit a fire and began shouting slogans against the V.P. Singh government. There had been talk that some of them planned to immolate themselves, but no one, including the approximately 200 policemen who were keeping watch on the protesting students, believed this would actually happen. Then, around 11.25, Rajeev Goswami arrived to join the protestors. He was walking towards us from the opposite end of the road. Before anyone knew what was happening, he had lit a match and set himself on fire; he had already poured kerosene on himself. I rushed towards the boy and managed to shoot a few frames before policemen in plainclothes grabbed him, doused the fire and bundled him off to hospital.

'Rajeev Goswami survived, but many other students who followed his example in different parts of the country did not. Rajeev later contested the Delhi University Students Union elections and dabbled in politics for a while before fading into obscurity.'

Photo copyright © 1990 / AFP / Raveendran

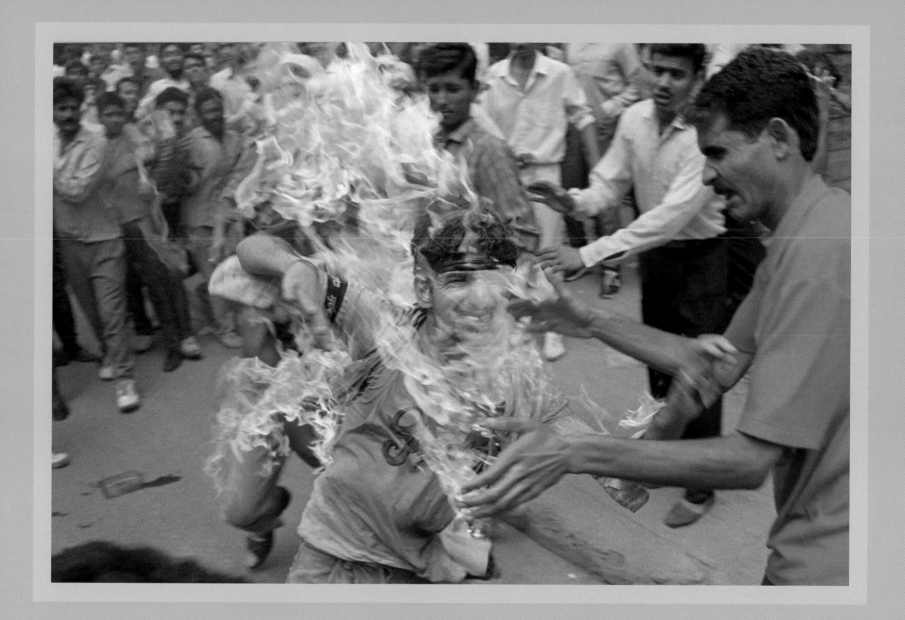

D. Ravinder Reddy

Kar sevaks storm the Babri Masjid, Ayodhya, 1992

'The demolition of the Babri Masjid at Ayodhya on 6 December 1992 is without doubt a milestone in the history of modern India and, whether by fortune or misfortune, I came to be associated with it because of this picture.

'I had reached Ayodhya from Hyderabad on the night of 5 December. I was apprehensive that there would be a breakdown of law and order and the police would have to open fire to disperse the crowd of kar sevaks who were demanding that a Ram temple be built at the site of the Babri Masjid. I certainly did not imagine that the mosque would be reduced to rubble while the police and para-military forces stood around as mere spectators. The demolition started at around noon on 6 December. Scores of photographers who were at the scene rushed to take pictures of the event, but they were all attacked by the kar sevaks. They were manhandled, their cameras smashed and film rolls snatched away. Unlike the other photographers, I did not have any camera bags; all I had was a haversack, with my camera hidden in it. And again, unlike most of them, I did not approach the mosque from the front. I went to the rear and rushed into the mosque complex with a group of slogan-shouting kar sevaks. Everybody thought I was one of them. Only when I was inside the complex did I take out my camera and quickly shot off a few frames. Within seconds, some kar sevaks realized that I had taken their pictures and tried to snatch my camera but I managed to dodge them and run out of the complex. They went back to the job of demolishing the mosque.

'I knew that I had the best pictures I could hope for under the circumstances and returned to New Delhi the same evening. Most other photographers chose to stay on in Ayodhya till the demolition was completed, giving the kar sevaks enough time to spot them and destroy their film and cameras.'

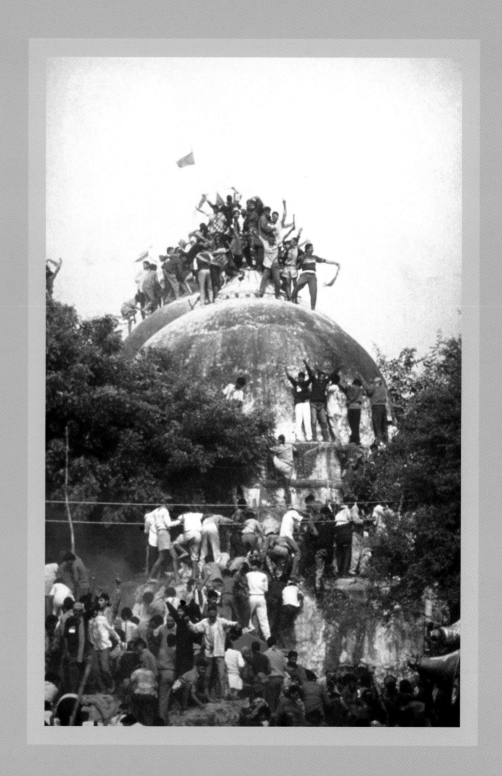

Sherwin Crasto

The body of a riot victim lies on the street, Bombay, 1993

Following the demolition of the Babri Masjid on 6 December 1992, two rounds of communal riots
broke out in Bombay in December 1992 and January 1993 which left 900 dead and over 2000 injured;
356 died in police firing and eighty in mob action.

156

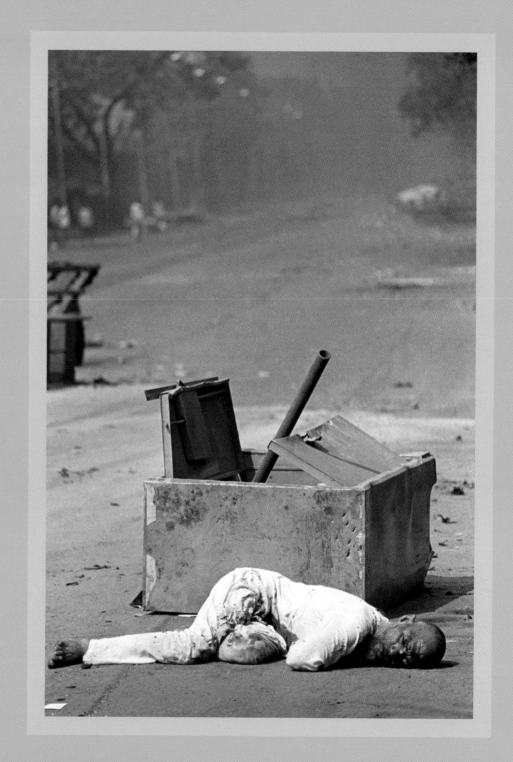

Jitender Gupta

Riot in the Uttar Pradesh Assembly, Lucknow, 1997

The ugly side of Indian politicians was revealed to the nation when legislators got physical during a debate in the Uttar Pradesh Assembly on 21 October 1997. There were pitched battles in the well of the house, furniture was flung across the hall and steel microphones were ripped out and used as missiles. All this happened in front of television cameras that telecast the scene live to millions of households. By the time order was restored, forty-one legislators had been injured.

Photo courtesy Outlook

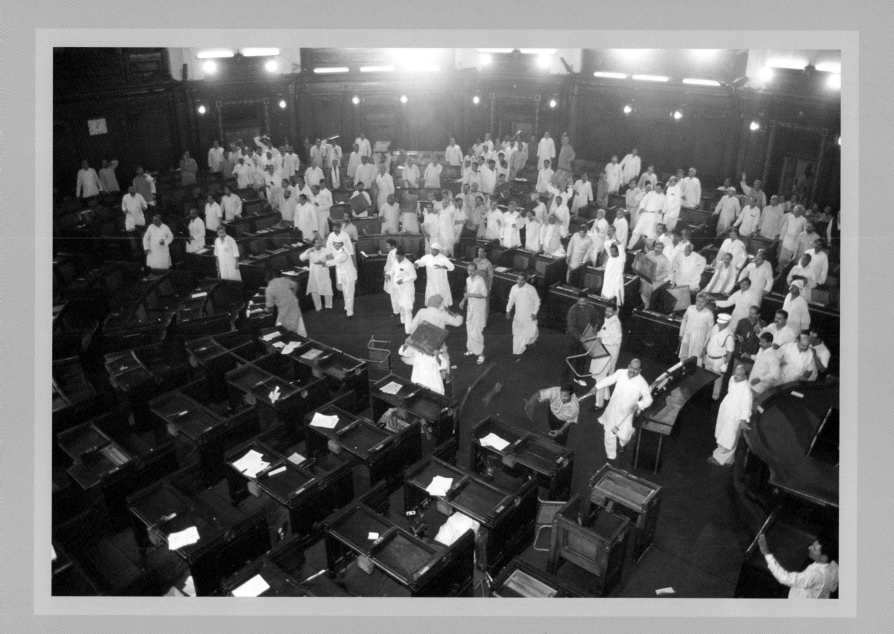

Prashant Panjiar

Indian soldiers with flag during the Kargil war, Mushkoh Valley, Jammu and Kashmir, June 1999

'Like Felice Beato's photograph (p. 66), this too is a constructed image of military triumph. However, there is one major difference. While this is not a photograph of a spontaneous event, it captures the genuine sense of jubilation that the Indian soldiers felt at being victorious; through this image they reached out directly to fellow Indians, something they had been prevented from doing by the politicians and generals sitting in Delhi.

'The Kargil war was a very frustrating war for us photojournalists to cover. Perhaps because the military and political leadership had failed to react in time to the Pakistani incursions, they tried their best to keep the media away from the real action. While our soldiers fought courageously in the field, with inadequate equipment and often with too much demanded of them, their bosses sitting far away gave sanitized briefings to the press; there was a blanket ban on the soldiers interacting directly with the media. This photograph was taken at the end of the war, when Indian troops had won the last battles in the Mushkoh Valley and a few journalists managed to give the Brigade Headquarters the slip. We were surprised at the welcome we got; the soldiers were eager to share with everyone the joy of a hard won victory, and they finally had an opportunity to do that.'

Photo courtesy Outlook

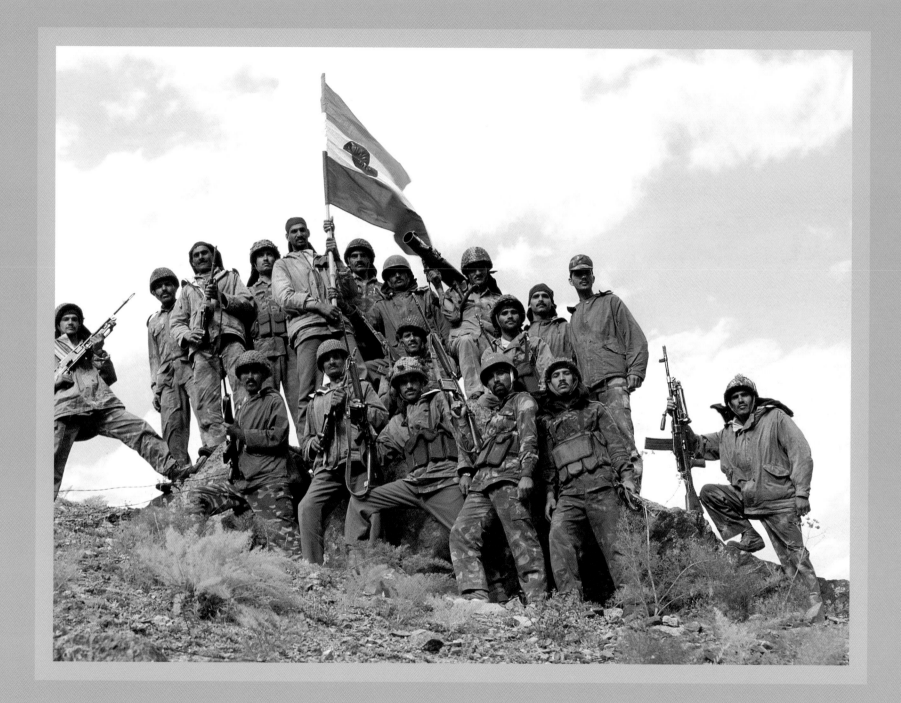

Police and firemen try to put out the flames engulfing the coaches of the
Sabarmati Express in Godhra, Gujarat, 2002

On 27 February 2002, two coaches of the Sabarmati Express carrying Hindu kar sevaks returning from
Ayodhya were set on fire at the Godhra station in Gujarat. Fifty-eight people were burned to death.
Almost immediately, armed mobs took over the streets of Gujarat, hunting out and slaughtering Muslim
men, women and children.

Photo courtesy Associated Press

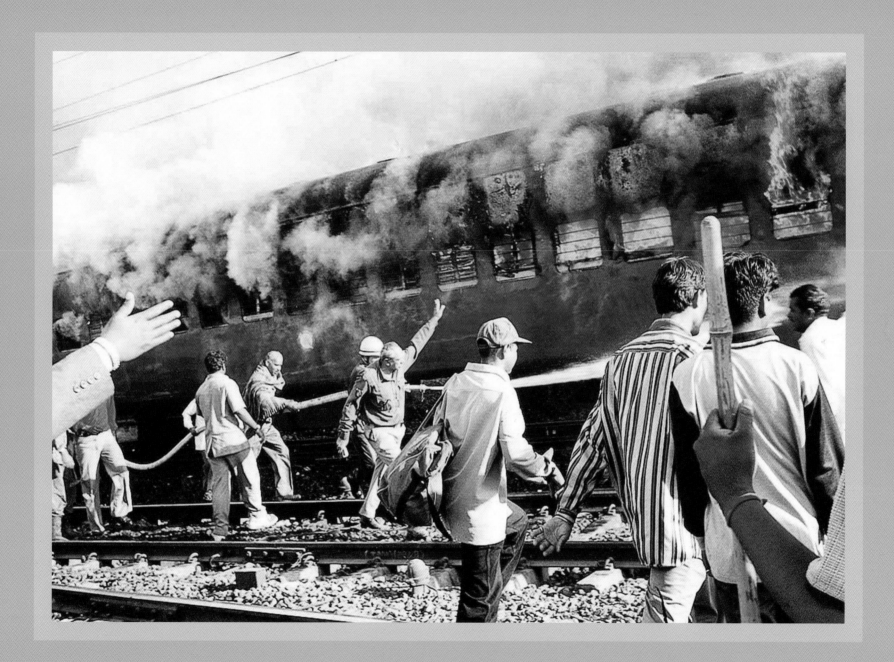

Arko Dutta

Qutubuddin Naseeruddin pleads for his life after being surrounded by a
mob of Hindu militants, Ahmedabad, 2002

This picture of a Muslim man begging the police to save him and his family from the rioting mobs came
to symbolize the insanity and terror that gripped Gujarat during the communal riots of early 2002.
Qutubuddin survived; most others did not.

Photo courtesy Reuters / Arko Dutta

164

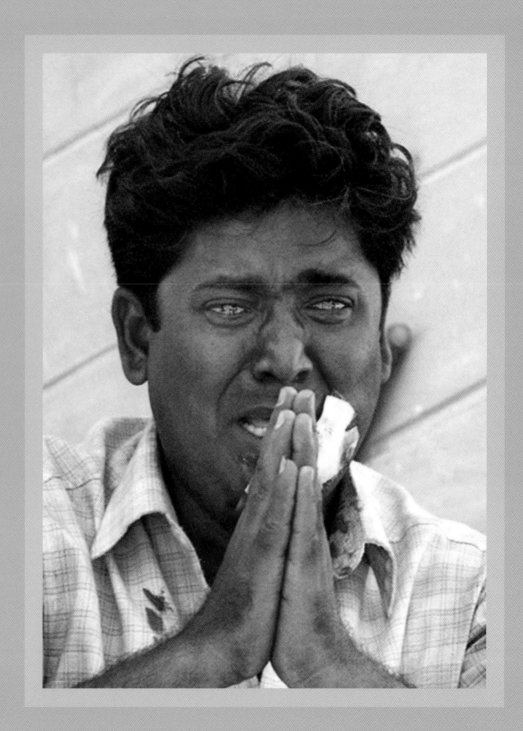

Prashant Panjiar

Indian flag, Hindon air base, 1997

'It was one of those routine assignments. An entire press party was taken in a bus to the Hindon air base to witness an air force para-jumper trying to create a record of jumping with the largest flag ever to commemorate India's fiftieth year of independence. Though the jump was abandoned that day due to very strong winds, the flag was opened out on the tarmac so that the press could get pictures of the para-jumper with it. The television crews and photographers had packed up when a strong gust of wind sent the flag flying in the air. In India's fiftieth year of independence this image took on a potent meaning of its own.'

Photo courtesy Outlook

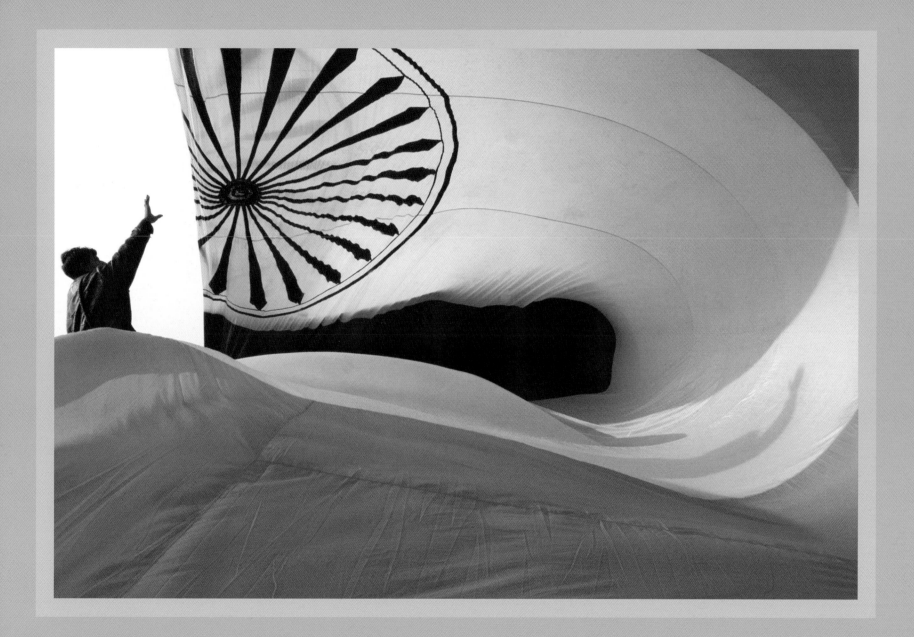